BASQUIAT

Published in 2019 by
Laurence King Publishing Ltd
361–373 City Road
London EC1V 1LR
United Kingdom
Tel: +44 20 7841 6900
Fax: +44 20 7841 6910
E-mail: enquiries@laurenceking.com
www.laurenceking.com

Translated from the Italian by Edward Fortes

A catalog record for this book is available from the British Library

ISBN: 978-1-78627-415-1

Printed in Italy

PAOLO PARISI

BASQUIAT

A GRAPHIC NOVEL

TRANSLATION BY EDWARD FORTES

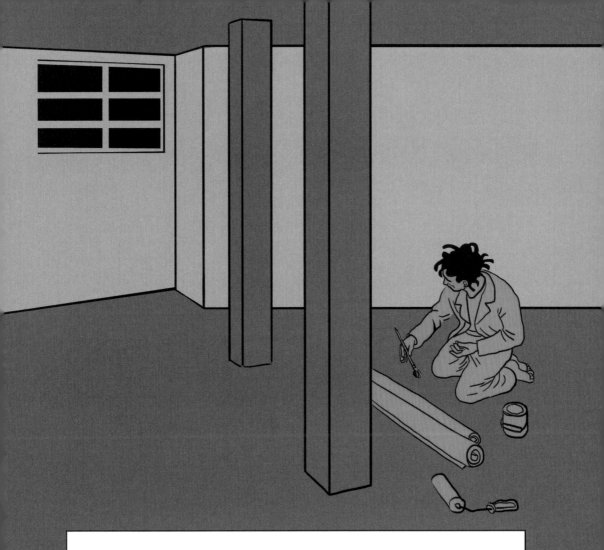

FOREWORD

"I DON'T KNOW HOW TO DESCRIBE MY WORK IN ANY OTHER WAY. IT'S LIKE ASKING MILES DAVIS, 'HOW DOES YOUR TRUMPET SOUND?'"

Using the artist's own words is the best way of summing up what making art is for Jean-Michel Basquiat: pure improvisation, violence, instinct, and passion. The most common (and most trivial) mistake is to fail to see an underlying rationale behind any of these four nouns. Indeed, in Basquiat we see a detailed analysis of the society in which he lived, a constant anger in his attempts to protect or immunize it against suffering, and the innate strength that will get him "to the top," among the biggest stars of the 1980s New York art scene.

A few preliminary notes are required prior to the reading of this book. Let's start with the most obvious: each chapter is specifically connected to facts and events drawn from Basquiat's life. "The Radiant Child" is the title of a magazine article that appeared

in *Artforum* in December 1981, written by the New York artist and critic Rene Ricard. The article was crucial to the development of the young painter of Haitian origin's career, bringing his early work into the spotlight.

Ricard writes: "If Cy Twombly and Jean Dubuffet were to have a child and put him up for adoption, it would be Jean-Michel. He has all the elegance of Twombly—whose work has the same origin in graffiti—coupled with the Art Brut of a young Dubuffet. The difference is that Dubuffet's ideas required preliminary explanation, a text of their own, in order to be understood, while in Jean-Michel's work the ideas are integrated into, and articulated by, the very need to paint." The title ("The Radiant Child") also refers to his childhood, a time when Basquiat was able to store up the first tangible motifs that would recur so powerfully later on, throughout his work as a painter. One need only think of his much-cherished copy of *Gray's Anatomy*, a book of anatomical illustrations.

"New York/New Wave" is the title of the famous exhibition curated by Diego Cortez in February of the same year (1981). It was Basquiat's first major group show, at which a number of gallery owners—most notably, Annina Nosei—recognized the strength of his work. "New York/New Wave" was a kind of "happening;" anyone who was part of the cultural ferment of the early 1980s New York underground scene was involved: there were No Wave musicians and art punk, performances and readings—and obviously, graffiti.

"New Art/New Money," on the other hand, was the title on the cover page of the *New York Times* magazine of 10 February 1985: Basquiat appears wearing no shoes and a stylish, charcoal gray Armani suit stained with acrylic. He looks toward us, confident and detached. At a certain point the American art market underwent a radical change, and with it the figure of the gallery owner: no longer a refined, cultured presence at the service of the individual artist and his or her world, they began to break all ethical and rational codes, giving way to a market characterized by savage buying and selling, rivers of money, and a commodification of the art-object that reflected a new "star system." Basquiat becomes part of this circuit; having desperately wanted to get into it, he ends up being consumed by it, with no way of going back.

"Andy Warhol" is dedicated to the father of Pop Art and his brief artistic relationship with Basquiat. It's impossible to think of these two as separate entities, whether in life or their reciprocal artistic output.

"Riding With Death" is the title of one of Basquiat's last paintings, completed shortly before his death in 1988. Its style is simple, sparse, fierce: a horseman rides a skeleton, galloping toward a sadly premature and dramatically pre-written end.

There is a very specific reason as to why I have chosen to use certain colors. To tell the biographical story you have in your hands, I looked back at the whole of Basquiat's

oeuvre. These are the colors that jump out the most in his early work, conveying power, transgression, and elegance. It is therefore an homage, an attempt to make a graphic novel out of something that is not. If we think of the same process in reverse, we might look to Keith Haring, or Roy Lichtenstein, who dipped into a certain kind of ¨pop¨ aesthetic when creating their own personal universe.

The same goes for the notebook pages. Basquiat wrote, drew, and painted compulsively, all the time, and everywhere. Many of his sketchbooks consist of notes, poems, single sentences, crossings out, and doodles. Simulating one of Jean-Michel's diaries helped me to retell moments or points of view based on strictly personal events—a plot device that also has a strong graphic quality.

Another tribute was the choice to include very specific photographic references. In addition to the myriad polaroids of Warhol and Michael Holman, I pay homage to other authors in some vignettes. One example is Bruce Davidson, a photographer with an entirely different background, famous for the shots from his 1980 *Subway* series. He is explicitly referenced in the third vignette on page 42.

There is much that is true in this story—but of course the whole is translated into a narrative fiction that requires the betrayal of some biographical elements. As in my other books, narrative choice has occasionally led to gaps in other areas. I have, therefore, included an extensive bibliography at the end of the book, which is designed to help the reader navigate a very specific and complex world like Basquiat's. As well as Phoebe Hoban's unofficial biography, I would highly recommend Michel Nuridsany's biographical study of Basquiat, which is full of cultural and socio-political references, and provides relevant context for every moment of the artist's short life. Last but not least, I would recommend Achille Bonito Oliva's short and succinct text, *Basquiat and American Graffiti*, which could not help but consider the relationship between graffiti, American culture, and the European Transavantgarde movement of the 1980s.

One last note: as a teenager Jean-Michel drew comic strips, and there is a series of consecutive drawings from 1978 entitled *The Comic Book*.

Finally, this book constitutes another milestone on a course already laid out by my previous work, all of which is bound by a common thread combining jazz, art, painting and process, rhythm, rigor, improvisation, and spontaneity. Every biography I have tackled, including this one, considers the connections therein: a subtle, naked truth, as unvarnished and unadorned, as real and concise as life itself.

I hope you enjoy it.

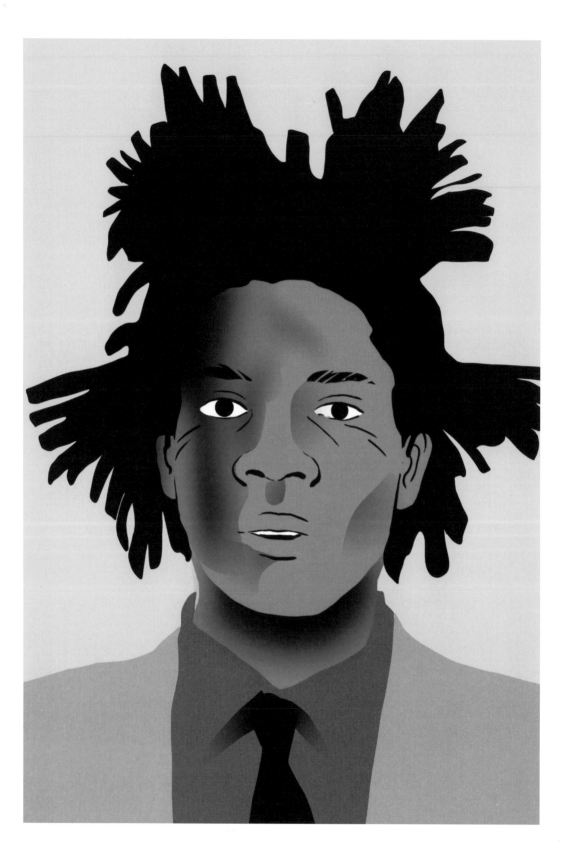

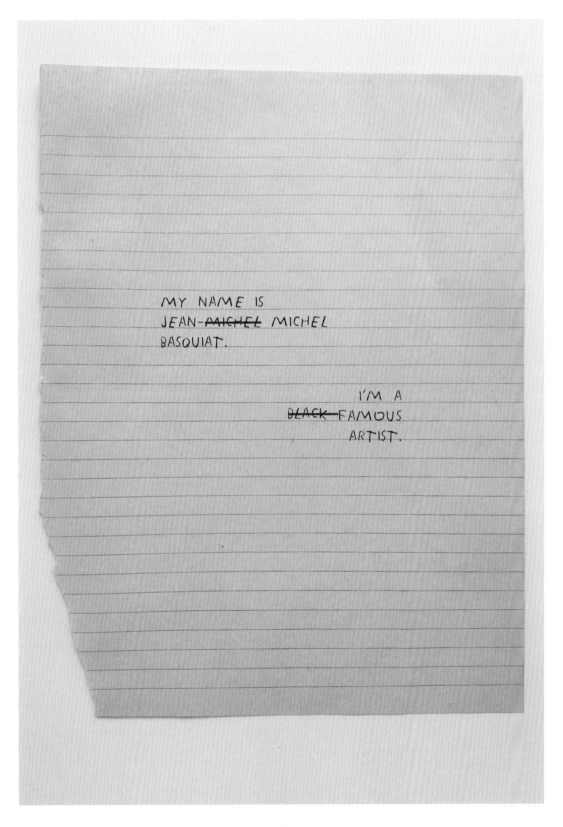

THE
RADIANT
CHILD

1967

1978

1981

1983

1985

1987

13

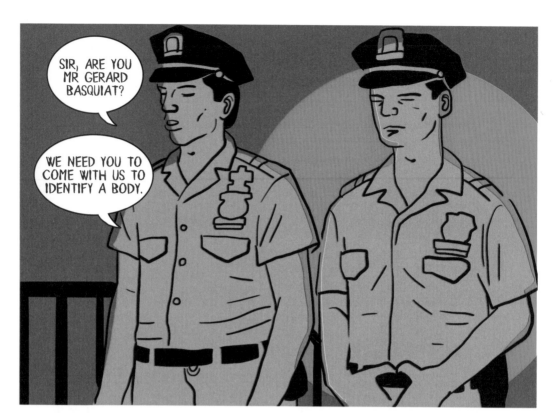

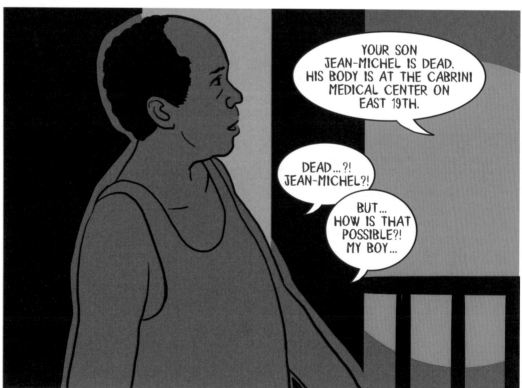

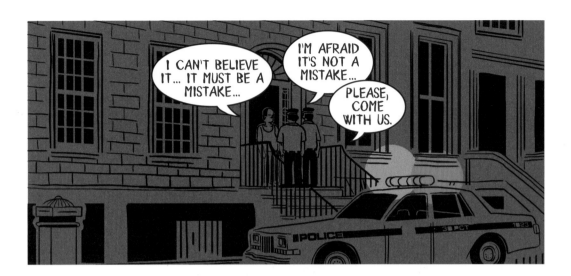

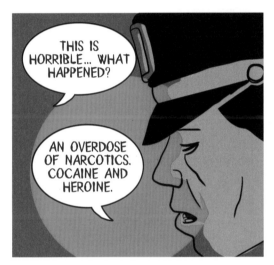

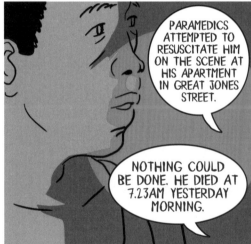

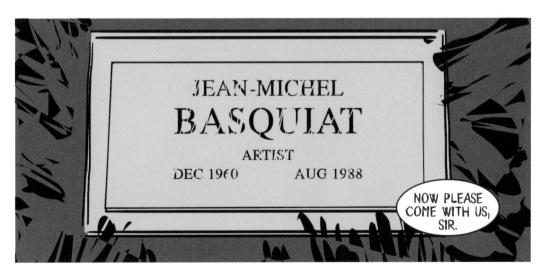

MY NAME IS GERARD BASQUIAT, FATHER OF THE ARTIST JEAN-MICHEL. IT WAS 1968, AND AT FIRST WE LIVED IN AN APARTMENT IN FLATBUSH, BROOKLYN. JEAN'S MOTHER, MATILDE, LOVED HIM VERY MUCH. BUT I STARTED TO SEE OTHER WOMEN AND SHE WENT THROUGH PHASES OF BAD DEPRESSION, BOTH OF WHICH CAUSED IRREPARABLE DAMAGE TO OUR RELATIONSHIP.

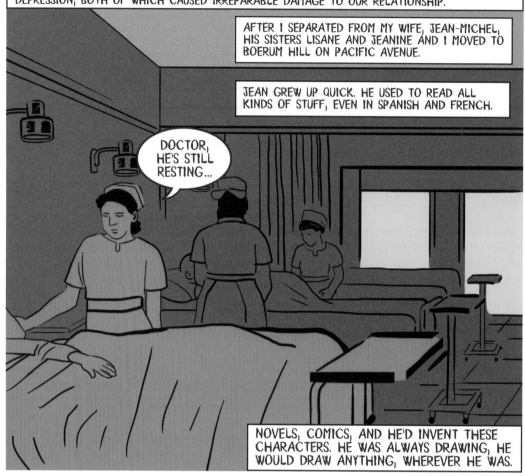

AFTER I SEPARATED FROM MY WIFE, JEAN-MICHEL, HIS SISTERS LISANE AND JEANINE AND I MOVED TO BOERUM HILL ON PACIFIC AVENUE.

JEAN GREW UP QUICK. HE USED TO READ ALL KINDS OF STUFF, EVEN IN SPANISH AND FRENCH.

DOCTOR, HE'S STILL RESTING...

NOVELS, COMICS, AND HE'D INVENT THESE CHARACTERS. HE WAS ALWAYS DRAWING, HE WOULD DRAW ANYTHING, WHEREVER HE WAS.

WE WON'T DISTURB HIM FOR LONG...

LET'S DO A QUICK CHECK-UP...

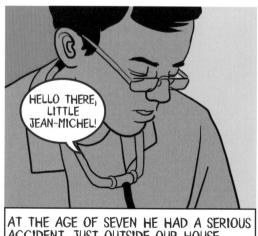

HELLO THERE, LITTLE JEAN-MICHEL!

AT THE AGE OF SEVEN HE HAD A SERIOUS ACCIDENT, JUST OUTSIDE OUR HOUSE.

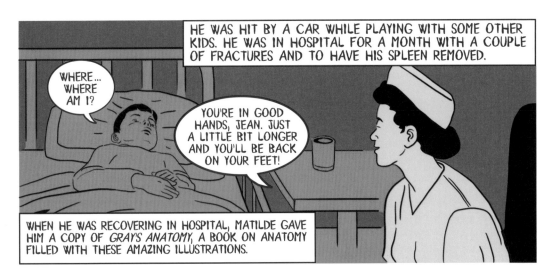

HE WAS HIT BY A CAR WHILE PLAYING WITH SOME OTHER KIDS. HE WAS IN HOSPITAL FOR A MONTH WITH A COUPLE OF FRACTURES AND TO HAVE HIS SPLEEN REMOVED.

WHERE... WHERE AM I?

YOU'RE IN GOOD HANDS, JEAN. JUST A LITTLE BIT LONGER AND YOU'LL BE BACK ON YOUR FEET!

WHEN HE WAS RECOVERING IN HOSPITAL, MATILDE GAVE HIM A COPY OF *GRAY'S ANATOMY*, A BOOK ON ANATOMY FILLED WITH THESE AMAZING ILLUSTRATIONS.

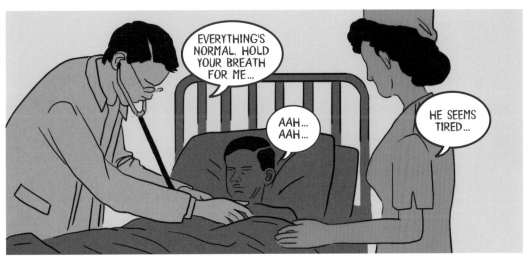

EVERYTHING'S NORMAL. HOLD YOUR BREATH FOR ME...

AAH... AAH...

HE SEEMS TIRED...

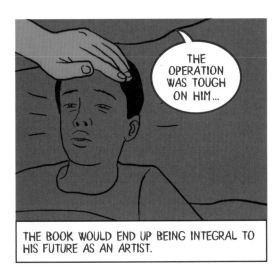

THE OPERATION WAS TOUGH ON HIM...

THE BOOK WOULD END UP BEING INTEGRAL TO HIS FUTURE AS AN ARTIST.

REST UP, JEAN-MICHEL...

YOU'VE GOT A WHOLE LIFE AHEAD OF YOU...

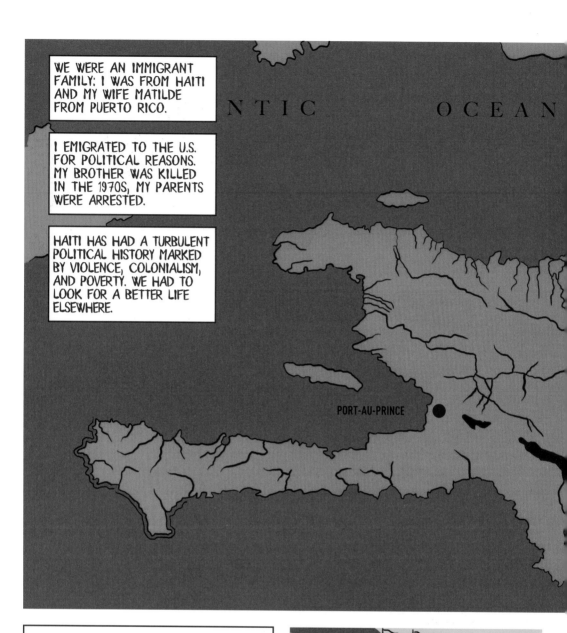

WE WERE AN IMMIGRANT FAMILY; I WAS FROM HAITI AND MY WIFE MATILDE FROM PUERTO RICO.

I EMIGRATED TO THE U.S. FOR POLITICAL REASONS. MY BROTHER WAS KILLED IN THE 1970S, MY PARENTS WERE ARRESTED.

HAITI HAS HAD A TURBULENT POLITICAL HISTORY MARKED BY VIOLENCE, COLONIALISM, AND POVERTY. WE HAD TO LOOK FOR A BETTER LIFE ELSEWHERE.

PORT-AU-PRINCE

I WAS A JAZZ AND CLASSICAL MUSIC FAN, AND I REMEMBER JEAN-MICHEL WOULD COME AND ASK WHAT I WAS LISTENING TO. I WOULDN'T LET HIM TOUCH MY RECORDS, BUT THERE WAS ALWAYS MUSIC AROUND AND HE WOULD LISTEN TO ALL KINDS OF STUFF. HIS FAVORITES WERE MILES DAVIS AND BACH.

HIS GRANDFATHER WAS A MUSICIAN, SO JEAN HAD BEEN AROUND JAM SESSIONS AND LATIN MUSIC FROM A VERY YOUNG AGE.

HIS MOTHER MATILDE WAS VERY STRICT WITH JEAN, BUT SHE WAS ALSO VERY CLOSE TO HIM.

SHE OFTEN TOOK HIM TO THE THEATER OR TO MUSEUMS; JEAN'S FAVORITE PAINTING WAS *GUERNICA* BY PICASSO.

I DON'T KNOW IF I WAS A GOOD FATHER TO JEAN. WE NEVER TALKED ABOUT IT, OR MAYBE WE NEVER HAD TIME TO. I ALWAYS RESPECTED HIS PRIVACY AND WHAT HE WANTED; I TRIED TO BE AROUND WITHOUT INTRUDING ON HIS PRIVATE LIFE. NOW I MISS HIM MORE THAN EVER.

LE SEX SHOPPE
VIDEO 25¢ PEEPS
THE ONE STOP SEX SHOP

★ VIDEO TAPE DISCOUNT ★

HOT
X
X
X
O
X
X
X
T
X

HOT
VIDEO
PEEPS
25¢

SEX

NO TAX
Video SALE
XXX RATED

• BONDAGE •
VIDEO TAPES
X X X

PORN
G·I·R·L·S

MARCH, 1978

I MET THIS GUY, AL DIAZ. HE'S ORIGINALLY
FROM PUERTO RICO. MAKES EVERYONE
CALL HIM "BOMB I." WE NORMALLY MEET
UP AROUND 42ND; THERE ARE ALL KINDS
OF PEOPLE THERE, SEX SHOPS AND ADULT
MOVIE THEATERS.

WE IMMEDIATELY HIT IT OFF. HE TALKS TO
ME ABOUT THE BROOKLYN GANGS, AND DOING
PIECES AROUND TOWN. HE HAS EVERYTHING
YOU NEED.

WE'RE SEEING EACH OTHER MORE AND MORE.

I SUGGEST WE DO SOMETHING TOGETHER.

IT'S MORE OF A MAD IDEA THAN A PROJECT.

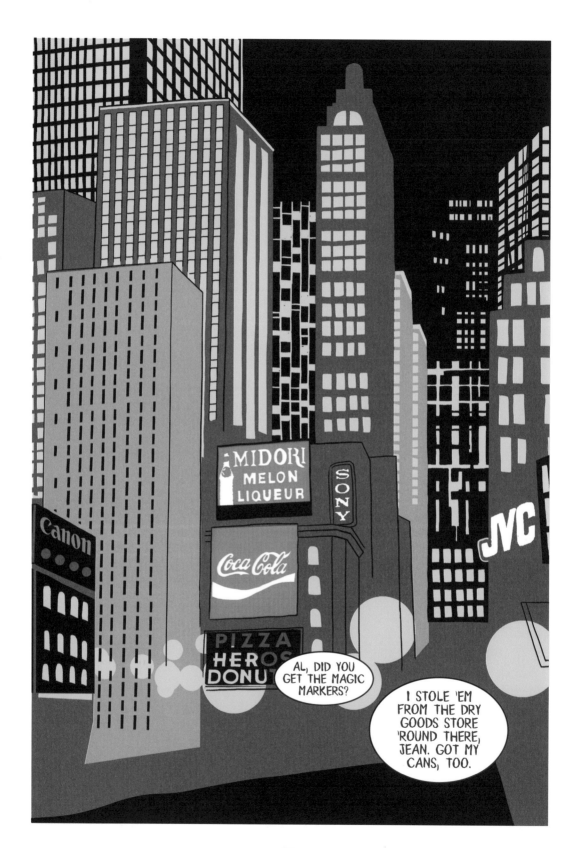

22

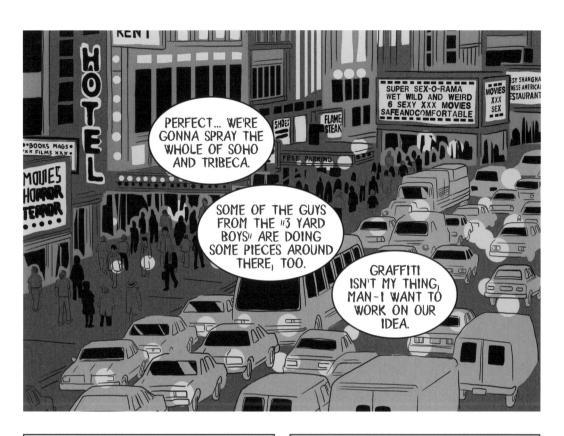

PERFECT... WE'RE GONNA SPRAY THE WHOLE OF SOHO AND TRIBECA.

SOME OF THE GUYS FROM THE "3 YARD BOYS" ARE DOING SOME PIECES AROUND THERE, TOO.

GRAFFITI ISN'T MY THING, MAN–I WANT TO WORK ON OUR IDEA.

HERE I AM: MY NAME'S JEAN-MICHEL BASQUIAT; I'M 18 AND I WANT TO BE AN ARTIST.

RIGHT NOW I'M CHILLING WITH MY BUDDY AL DIAZ. WE SPEND OUR TIME WRITING PROVOCATIVE SLOGANS ON THE WALLS OF THE BIG APPLE UNDER THE NAME "SAMO©."

23

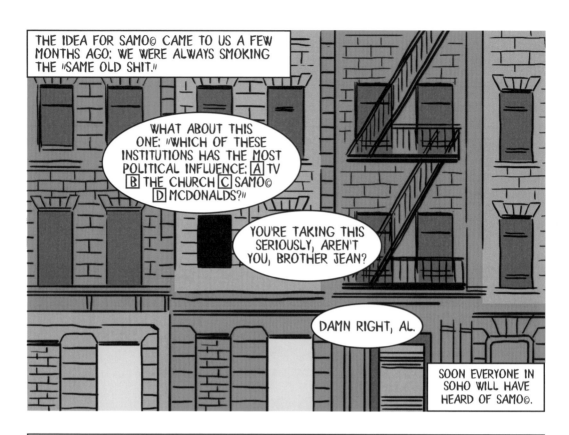

THE IDEA FOR SAMO© CAME TO US A FEW MONTHS AGO; WE WERE ALWAYS SMOKING THE "SAME OLD SHIT."

WHAT ABOUT THIS ONE; "WHICH OF THESE INSTITUTIONS HAS THE MOST POLITICAL INFLUENCE: A TV B THE CHURCH C SAMO© D MCDONALDS?"

YOU'RE TAKING THIS SERIOUSLY, AREN'T YOU, BROTHER JEAN?

DAMN RIGHT, AL.

SOON EVERYONE IN SOHO WILL HAVE HEARD OF SAMO©.

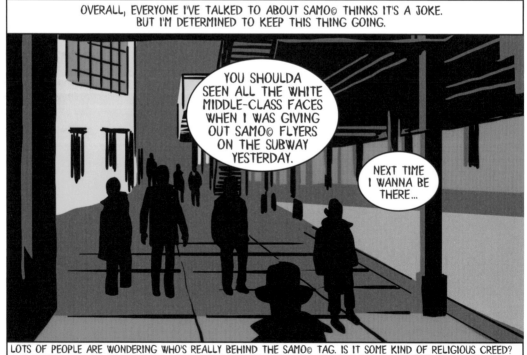

OVERALL, EVERYONE I'VE TALKED TO ABOUT SAMO© THINKS IT'S A JOKE. BUT I'M DETERMINED TO KEEP THIS THING GOING.

YOU SHOULDA SEEN ALL THE WHITE MIDDLE-CLASS FACES WHEN I WAS GIVING OUT SAMO© FLYERS ON THE SUBWAY YESTERDAY.

NEXT TIME I WANNA BE THERE...

LOTS OF PEOPLE ARE WONDERING WHO'S REALLY BEHIND THE SAMO© TAG. IS IT SOME KIND OF RELIGIOUS CREED? THE SUDDEN RISE OF AN UNKNOWN GANG? SOME SAY IT'S THE WORK OF SOME WHITE CONCEPT ARTIST ON A "BAD TRIP" GOING AROUND SPOUTING QUASI-EXISTENTIALIST PHRASES.

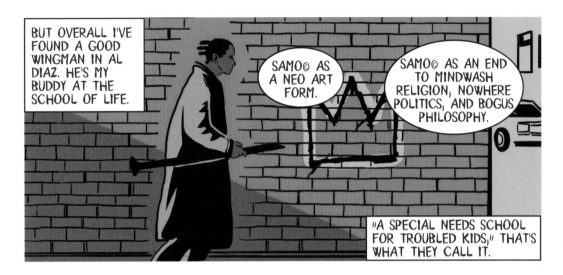

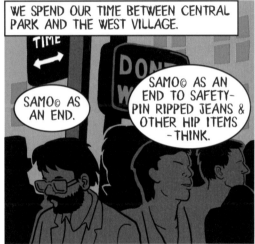

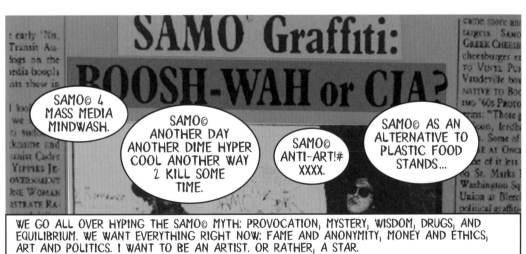

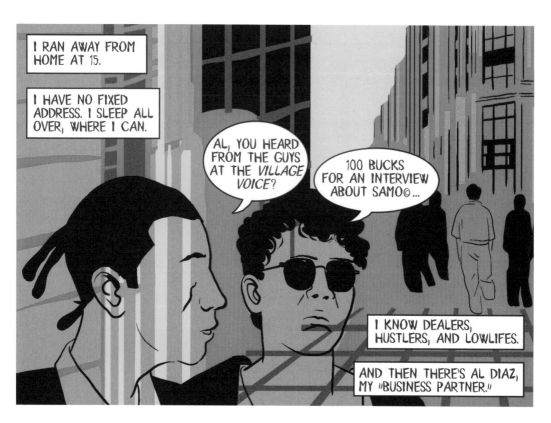

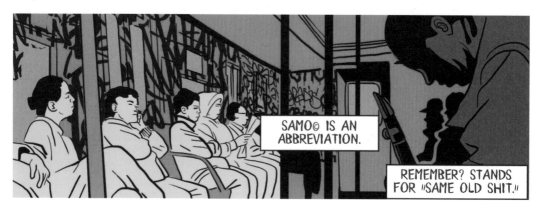

26

WHAT DO YOU MEAN?

THAT THIS THING IS GETTING BIG.

FOOD SHOP

EXPLAIN WHAT YOU MEAN...

SOHO NEWS AND VILLAGE VOICE ARE TALKING ABOUT US...

WE NEED TO MOVE PAST THIS SAMO© THING...

I DON'T GET IT, JEAN...

LEAVE IT TO ME AND YOU'LL SEE; SOON EVERYONE'S GONNA KNOW WHO WE ARE...

I DUNNO IF I'M WITH YOU ON THIS ONE...

TRUST ME, AL. SAMO© IS DEAD.

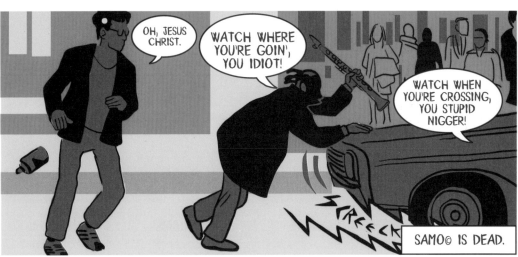

OH, JESUS CHRIST.

WATCH WHERE YOU'RE GOIN', YOU IDIOT!

WATCH WHEN YOU'RE CROSSING, YOU STUPID NIGGER!

SCREECK

SAMO© IS DEAD.

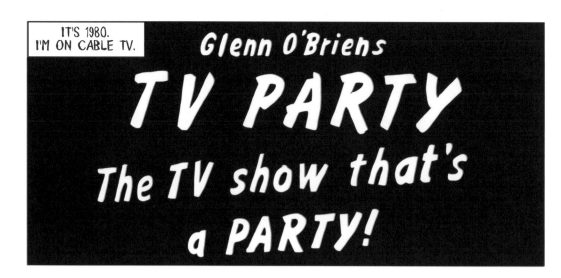

Glenn O'Briens
TV PARTY
The TV show that's a PARTY!

TV PARTY IS A SURREAL SHOW. GLENN IS A JOURNALIST, WRITER, AND CULTURAL RADICAL. HE'S ALWAYS IN RAY-BANS. ON HIS SHOW HE INTERVIEWS ALL THE LATEST HIP PERSONALITIES OR PEOPLE HE THINKS HAVE DONE WEIRD STUFF IN THE CITY.

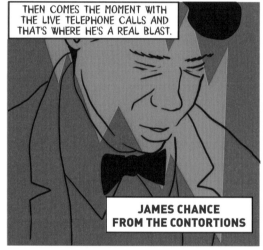

THEN COMES THE MOMENT WITH THE LIVE TELEPHONE CALLS AND THAT'S WHERE HE'S A REAL BLAST.

**JAMES CHANCE
FROM THE CONTORTIONS**

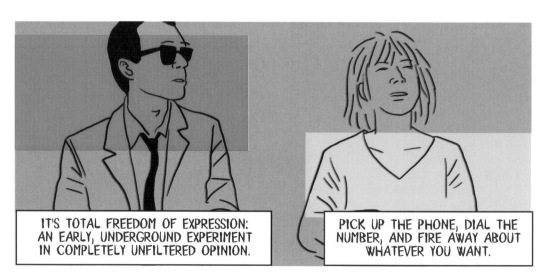

IT'S TOTAL FREEDOM OF EXPRESSION: AN EARLY, UNDERGROUND EXPERIMENT IN COMPLETELY UNFILTERED OPINION.

PICK UP THE PHONE, DIAL THE NUMBER, AND FIRE AWAY ABOUT WHATEVER YOU WANT.

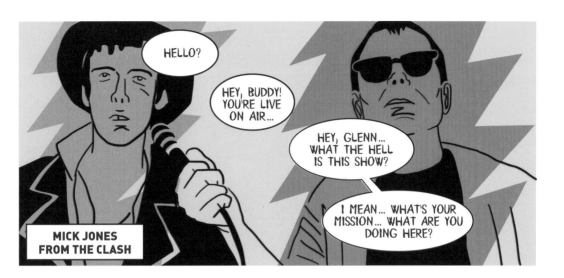

MICK JONES
FROM THE CLASH

DEBBIE HARRY
FROM BLONDIE

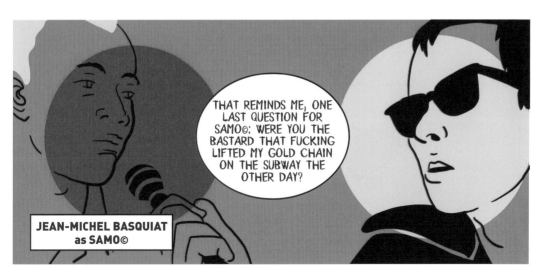

JEAN-MICHEL BASQUIAT
as SAMO©

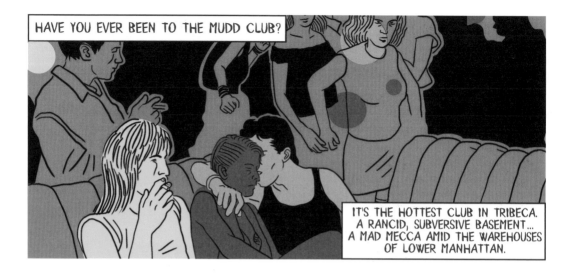

HAVE YOU EVER BEEN TO THE MUDD CLUB?

IT'S THE HOTTEST CLUB IN TRIBECA. A RANCID, SUBVERSIVE BASEMENT... A MAD MECCA AMID THE WAREHOUSES OF LOWER MANHATTAN.

IT'S LIKE A PUNK VERSION OF STUDIO 54: THEME NIGHTS, INCREDIBLE PARTIES, DRUGS OF ALL KINDS.

THERE'S THIS PROVOCATIVE, GLAMOROUS VIBE. DESIGNERS, PAINTERS, MUSICIANS, AND WOULD-BE ARTISTS ALL COME HERE.

IF YOU FEEL LIKE AN ALIEN IN YOUR EVERYDAY LIFE, MUDD IS FULL OF PEOPLE JUST LIKE YOU, READY TO HAVE A CRAZY NIGHT.

THE SOUNDS ARE EXPLOSIVE: JAZZ, FUNK, ELECTRONIC STUFF STRAIGHT OUTTA ENGLAND, OR BANDS THAT ARE BARELY KNOWN OUTSIDE DOWNTOWN.

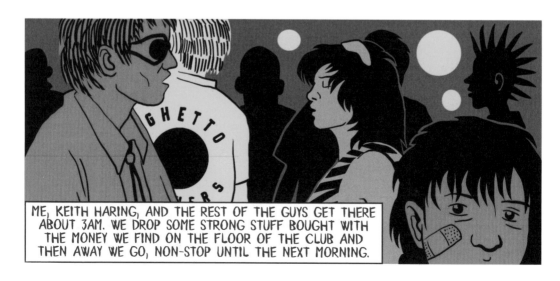

ME, KEITH HARING, AND THE REST OF THE GUYS GET THERE ABOUT 3AM. WE DROP SOME STRONG STUFF BOUGHT WITH THE MONEY WE FIND ON THE FLOOR OF THE CLUB AND THEN AWAY WE GO, NON-STOP UNTIL THE NEXT MORNING.

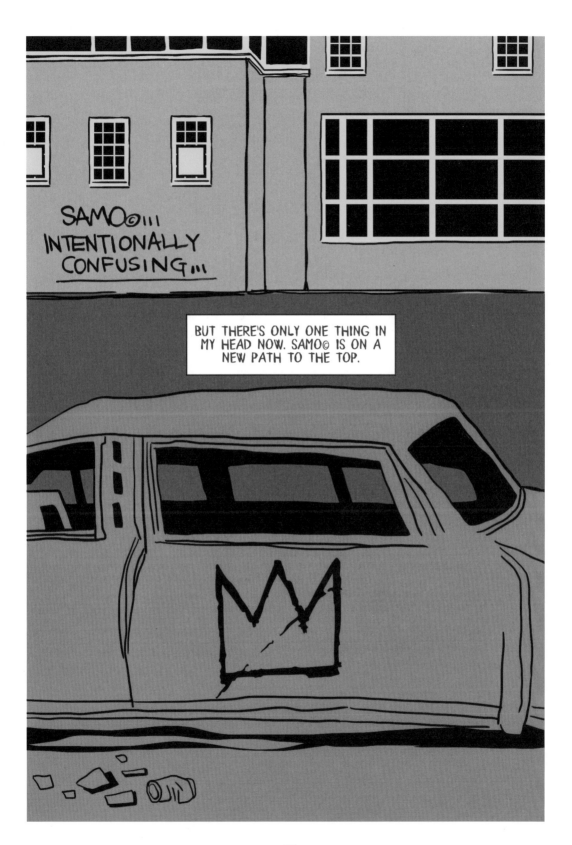

NEW YORK/ NEW NEW WAVE

MY NAME IS DIEGO CORTEZ; I'M AN ARTIST AND CURATOR. I WAS THE FIRST PERSON TO PROMOTE SAMO©'S-OR RATHER, JEAN-MICHEL BASQUIAT'S-WORK, IN 1981.

41ST & 7TH AVENUE

TIMES SQUARE SHOW

Art of the FUTURE

AT THE TIME I WAS PART OF THIS POLITICAL ART COLLECTIVE, "COLAB" (COLLABORATIVE PROJECTS INCORPORATED), WHICH BROUGHT TOGETHER ABOUT 50 ARTISTS FROM VARIOUS DISCIPLINES.

DISSATISFACTION WAS WIDESPREAD. ART GALLERIES WERE FULL OF CONCEPTUAL, MINIMALIST STUFF THAT DIDN'T REFLECT THE URBAN UNREST WE WERE ALL LIVING THROUGH.

SO, WE DECIDED TO RENT AN ABANDONED BUILDING ON WEST 41ST FOR A MONTH, NOT FAR FROM TIMES SQUARE.

IT WAS TO BE THE SITE OF A BIG GROUP EXHIBITION, THE "TIMES SQUARE SHOW." OUR AIM WAS TO REACH A BROAD, VARIED AUDIENCE OUTSIDE OF THE CONVENTIONAL ART GALLERY CIRCUIT.

!FREE!

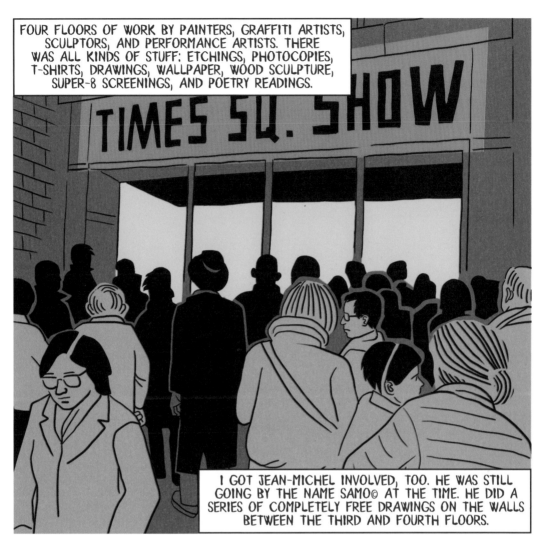

FOUR FLOORS OF WORK BY PAINTERS, GRAFFITI ARTISTS, SCULPTORS, AND PERFORMANCE ARTISTS. THERE WAS ALL KINDS OF STUFF: ETCHINGS, PHOTOCOPIES, T-SHIRTS, DRAWINGS, WALLPAPER, WOOD SCULPTURE, SUPER-8 SCREENINGS, AND POETRY READINGS.

I GOT JEAN-MICHEL INVOLVED, TOO. HE WAS STILL GOING BY THE NAME SAMO© AT THE TIME. HE DID A SERIES OF COMPLETELY FREE DRAWINGS ON THE WALLS BETWEEN THE THIRD AND FOURTH FLOORS.

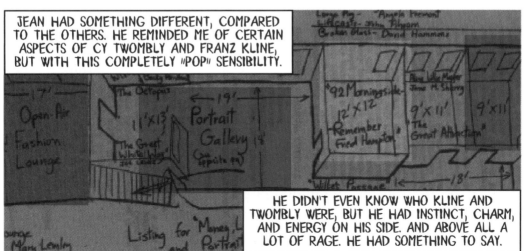

JEAN HAD SOMETHING DIFFERENT, COMPARED TO THE OTHERS. HE REMINDED ME OF CERTAIN ASPECTS OF CY TWOMBLY AND FRANZ KLINE, BUT WITH THIS COMPLETELY "POP" SENSIBILITY.

HE DIDN'T EVEN KNOW WHO KLINE AND TWOMBLY WERE, BUT HE HAD INSTINCT, CHARM, AND ENERGY ON HIS SIDE. AND ABOVE ALL A LOT OF RAGE. HE HAD SOMETHING TO SAY.

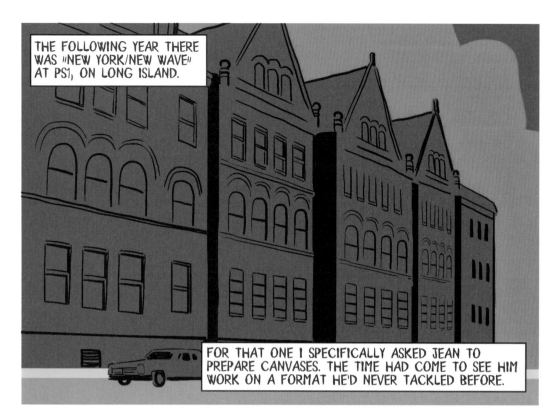

THE FOLLOWING YEAR THERE WAS "NEW YORK/NEW WAVE" AT PS1, ON LONG ISLAND.

FOR THAT ONE I SPECIFICALLY ASKED JEAN TO PREPARE CANVASES. THE TIME HAD COME TO SEE HIM WORK ON A FORMAT HE'D NEVER TACKLED BEFORE.

SPECIAL EXHIBITION GALLERY
"NEW YORK/NEW WAVE"
curated by DIEGO CORTEZ
with

HENRY CHALFANT
DAVID BYRNE
WILLIAM BURROUGHS
FAB FIVE
ROBERT FRIPP
JOHN HOLMSTROM

JOHN LURIE
ARTO LINDSAY
ROBERT MAPPLETHORPE
PUNK MAGAZINE
LYDIA LUNCH
RICHARD MCGUIRE
GLENN O'BRIEN
ALAN SUICIDE
SAMO
DNA
KEITH HARING

FRIDAY JUNE 17 7, 8:15. 9:30

THE BLANK GENERATION

AT THAT TIME SANDRO CHIA, THE MOST IMPORTANT EXPONENT OF THE EUROPEAN TRANSAVANTGARDE, LIVED IN NEW YORK. HE HAD NOTICED SOME OF BASQUIAT'S WORK AND I KNEW HE WOULD INVITE THE OWNERS OF SOME IMPORTANT GALLERIES.

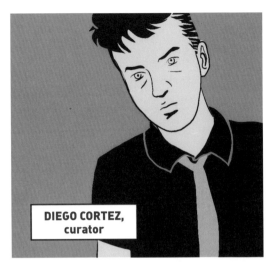

DIEGO CORTEZ,
curator

HE SHOWED UP AT THE EXHIBITION WITH
EMILIO MAZZOLI, AN ITALIAN GALLERIST, BRUNO
BISCHOFBERGER, WHO WAS SWISS, AND ANNINA NOSEI,
A YOUNG GALLERIST WHO HAD RECENTLY OPENED HER
OWN SPACE IN SOHO, ALSO OF ITALIAN ORIGIN.

MAZZOLI WAS A BIG FISH.
HE BOUGHT ALMOST
ALL OF JEAN-MICHEL'S
WORK FOR $10,000 AND
IMMEDIATELY OFFERED HIM
A SOLO SHOW IN ITALY.
NOT BAD FOR A PAINTER
WHO DIDN'T KNOW
ANYONE, REALLY.

FOR SOME JEAN'S WORK WAS STILL "GREEN," BUT MAZZOLI HAD SEEN HIS POTENTIAL. I OFFERED
UP MY SERVICES AS A MIDDLEMAN FOR THEM, TO ACCOMPANY JEAN-MICHEL ON THE TRIP AND
LOOK AFTER ALL THE ADMINISTRATIVE DETAILS. AT THE TIME JEAN WAS 20 YEARS OLD AND
DIDN'T HAVE A SHRED OF ID TO HIS NAME: NOT A PASSPORT NOR CREDIT CARD NOR HEALTH
INSURANCE. ORGANIZING HIM A TRIP ABROAD WAS NO PICNIC.

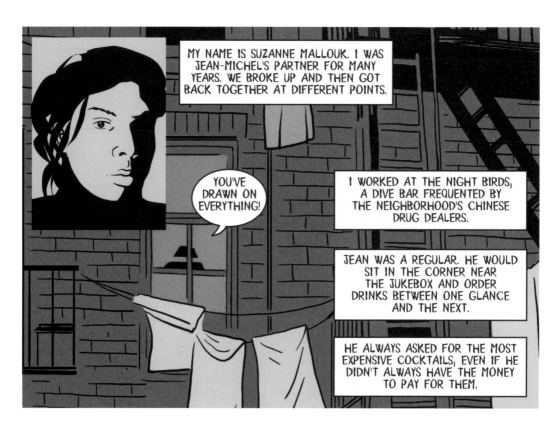

MY NAME IS SUZANNE MALLOUK. I WAS JEAN-MICHEL'S PARTNER FOR MANY YEARS. WE BROKE UP AND THEN GOT BACK TOGETHER AT DIFFERENT POINTS.

YOU'VE DRAWN ON EVERYTHING!

I WORKED AT THE NIGHT BIRDS, A DIVE BAR FREQUENTED BY THE NEIGHBORHOOD'S CHINESE DRUG DEALERS.

JEAN WAS A REGULAR. HE WOULD SIT IN THE CORNER NEAR THE JUKEBOX AND ORDER DRINKS BETWEEN ONE GLANCE AND THE NEXT.

HE ALWAYS ASKED FOR THE MOST EXPENSIVE COCKTAILS, EVEN IF HE DIDN'T ALWAYS HAVE THE MONEY TO PAY FOR THEM.

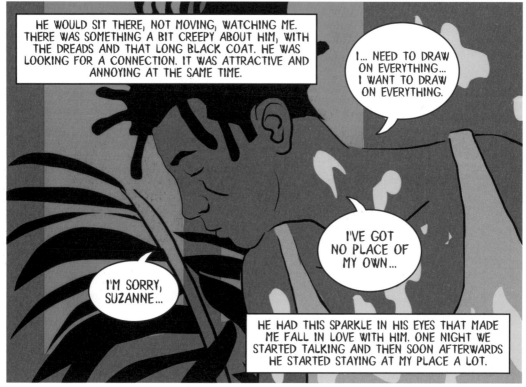

HE WOULD SIT THERE, NOT MOVING, WATCHING ME. THERE WAS SOMETHING A BIT CREEPY ABOUT HIM, WITH THE DREADS AND THAT LONG BLACK COAT. HE WAS LOOKING FOR A CONNECTION. IT WAS ATTRACTIVE AND ANNOYING AT THE SAME TIME.

I... NEED TO DRAW ON EVERYTHING... I WANT TO DRAW ON EVERYTHING.

I'VE GOT NO PLACE OF MY OWN...

I'M SORRY, SUZANNE...

HE HAD THIS SPARKLE IN HIS EYES THAT MADE ME FALL IN LOVE WITH HIM. ONE NIGHT WE STARTED TALKING AND THEN SOON AFTERWARDS HE STARTED STAYING AT MY PLACE A LOT.

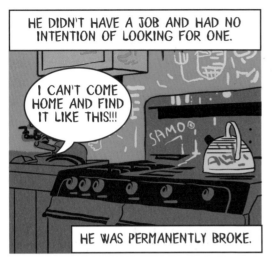

HE DIDN'T HAVE A JOB AND HAD NO INTENTION OF LOOKING FOR ONE.

I CAN'T COME HOME AND FIND IT LIKE THIS!!!

HE WAS PERMANENTLY BROKE.

THE NIGHT HE COVERED THE WHOLE HOUSE IN ACRYLIC, I LOST IT.

MY CLOTHES! MY RECORDS!

I'LL CLEAN EVERYTHING UP BY DAWN!

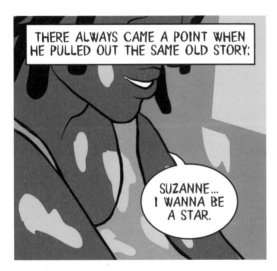

THERE ALWAYS CAME A POINT WHEN HE PULLED OUT THE SAME OLD STORY:

SUZANNE... I WANNA BE A STAR.

JEAN, STOP THIS MADNESS...

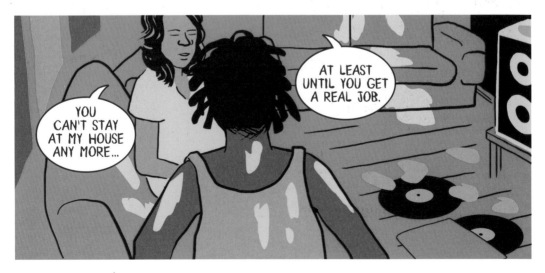

YOU CAN'T STAY AT MY HOUSE ANY MORE...

AT LEAST UNTIL YOU GET A REAL JOB.

LIVING WITH HIM WASN'T EASY. HIS SCHEDULE WAS ALL UPSIDE DOWN; HE SLEPT ALL DAY AND THEN GOT TO WORK DRAWING AND PAINTING AFTER SUNDOWN. ONE NIGHT HE WENT OUT, SAYING HE WAS GOING TO THE MUDD CLUB. I SAW HIM AGAIN TWO DAYS LATER WITH A COUPLE OF HIGH-CLASS SLUTS.

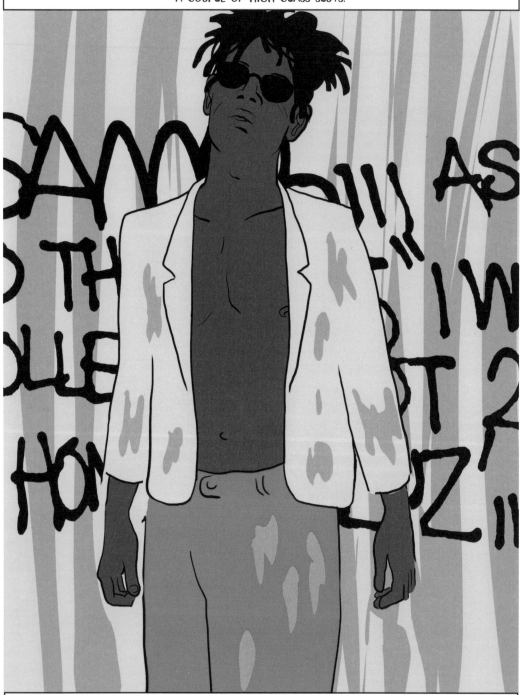

IT WAS OBVIOUS THEY'D SPENT THEIR NIGHTS TOGETHER AND GOT HIGH ON LOADS OF COKE. I WAS FURIOUS. I PACKED A BAG AND LEFT THE APARTMENT. WHICH WAS *MY* APARTMENT, TOO.

AT THAT TIME, WALKING AROUND ON YOUR OWN AT NIGHT AS A WOMAN WASN'T MUCH FUN.

BUT JEAN DIDN'T SEEM TO CARE. HE WAS TOO FOCUSED ON HIMSELF. IT WAS LIKE DEALING WITH A KID: SWEET AND NAIVE, TESTY AND PARANOID ALL AT THE SAME TIME.

I FELT LIKE HE DISTORTED THE TRUTH; LIKE HE WASN'T REALLY AWARE OF WHAT WAS GOING ON AROUND HIM.

I DON'T THINK HE COULD CONCEIVE OF THE IDEA THAT THERE WERE OTHER PEOPLE AROUND WHO DIDN'T GIVE A CRAP ABOUT HIS TRUE LIFE GOALS.

IF HE WASN'T WITH ME HE WAS ALWAYS OUT WITH OTHER WOMEN, WITH A FEW GRAMS OF COKE OR SPEED. HE WAS OVER THE TOP AND HE NEVER MISSED A CHANCE TO SHOW IT.

NEW YORK AT THAT TIME WAS THE ONLY CITY THAT COULD ACCEPT HIM, THE ONLY PLACE HE COULD SURVIVE.

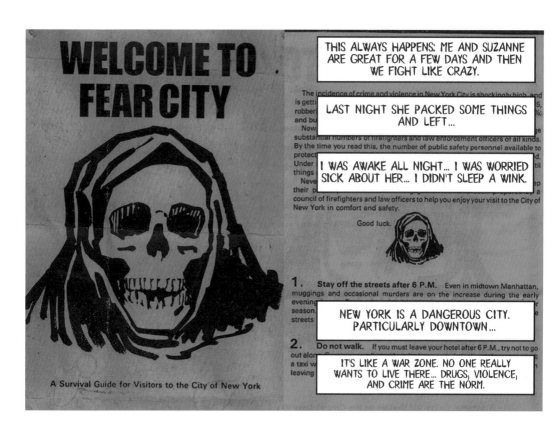

WELCOME TO FEAR CITY

A Survival Guide for Visitors to the City of New York

THIS ALWAYS HAPPENS; ME AND SUZANNE ARE GREAT FOR A FEW DAYS AND THEN WE FIGHT LIKE CRAZY.

LAST NIGHT SHE PACKED SOME THINGS AND LEFT...

The incidence of crime and violence in New York City is shockingly high, and is getti... robber... and bu...

Now... substantial numbers of firefighters and law enforcement officers of all kinds. By the time you read this, the number of public safety personnel available to protect...

Under... things...

Neve... their p... council of firefighters and law officers to help you enjoy your visit to the City of New York in comfort and safety.

I WAS AWAKE ALL NIGHT... I WAS WORRIED SICK ABOUT HER... I DIDN'T SLEEP A WINK.

Good luck.

1. Stay off the streets after 6 P.M. Even in midtown Manhattan, muggings and occasional murders are on the increase during the early evening... season... streets...

NEW YORK IS A DANGEROUS CITY. PARTICULARLY DOWNTOWN...

2. Do not walk. If you must leave your hotel after 6 P.M., try not to go out alon... a taxi w... leaving...

IT'S LIKE A WAR ZONE. NO ONE REALLY WANTS TO LIVE THERE... DRUGS, VIOLENCE, AND CRIME ARE THE NORM.

I CAN'T DESCRIBE IT AS ANYTHING OTHER THAN A SENSE OF COMMUNITY. OR SURVIVAL, IF YOU LIKE. THE FACT IS, THERE'S THIS HUGE SUPPORT NETWORK BETWEEN US ARTISTS, OR THOSE WHO ASPIRE TO BE; A BOND WE STRENGTHEN WITH EACH OTHERS' WORK. KEITH HARING, VITO ACCONCI, JOHN GIORNO, WILLIAM BURROUGHS, ANDY WARHOL, DEBBIE HARRY, JAMES CHANCE, ANYA PHILLIPS, AND JOHN LURIE. I COULD GO ON FOR HOURS.

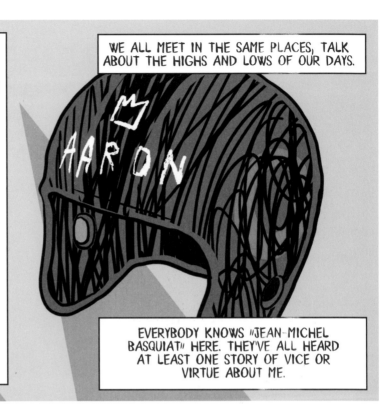

WE ALL MEET IN THE SAME PLACES, TALK ABOUT THE HIGHS AND LOWS OF OUR DAYS.

EVERYBODY KNOWS "JEAN-MICHEL BASQUIAT" HERE. THEY'VE ALL HEARD AT LEAST ONE STORY OF VICE OR VIRTUE ABOUT ME.

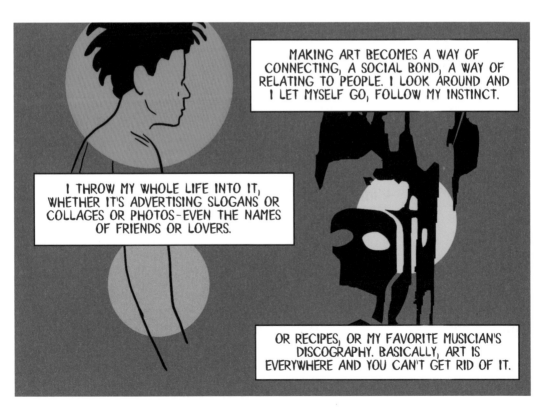

MAKING ART BECOMES A WAY OF CONNECTING, A SOCIAL BOND, A WAY OF RELATING TO PEOPLE. I LOOK AROUND AND I LET MYSELF GO, FOLLOW MY INSTINCT.

I THROW MY WHOLE LIFE INTO IT, WHETHER IT'S ADVERTISING SLOGANS OR COLLAGES OR PHOTOS—EVEN THE NAMES OF FRIENDS OR LOVERS.

OR RECIPES, OR MY FAVORITE MUSICIAN'S DISCOGRAPHY. BASICALLY, ART IS EVERYWHERE AND YOU CAN'T GET RID OF IT.

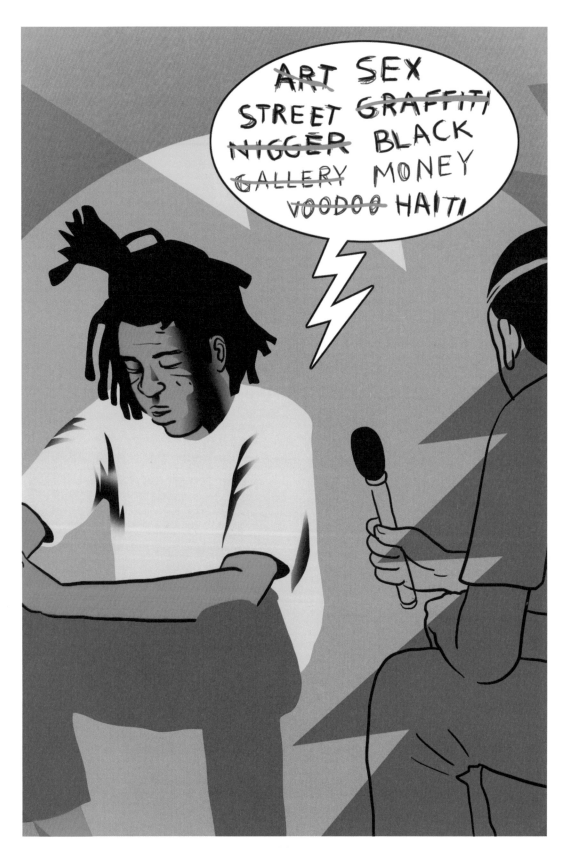

NOVEMBER, 1982

TODAY I MET PAUL TSCHINKEL AND MARC H. MILLER
FOR AN INTERVIEW AT MY APARTMENT IN CROSBY
STREET.
THIS IS FROM OUR CONVERSATION:

MILLER: "WHAT ARE YOU, HAITIAN-PUERTO RICAN?...."
JMB: "I WAS BORN HERE. MY MUM IS FOURTH-
GENERATION PUERTO RICAN, MY DAD HAS HAITIAN
ORIGINS."
MILLER: "DO YOU FEEL IT'S SOMETHING THAT'S
PRESENT IN YOUR ART?"
JMB: "WHAT, GENETICALLY?"
MILLER: "OR CULTURALLY... HAITI IS KNOWN FOR ITS
ART, FOR EXAMPLE...."
JMB: "THAT'S WHY I SAID GENETICALLY. I'VE NEVER
BEEN THERE. AND I GREW UP IN THE GREAT AMERICAN
VOID, AND WITH A TV, ABOVE ALL...."
MILLER: "NO HAITIAN PRIMITIVES ON YOUR WALLS?"
JMB: "AT MY HOUSE? WHAT DO YOU MEAN, HAITIAN
PRIMITIVES? LIKE PEOPLE NAILED TO THE WALL?"
MILLER: "I MEAN PAINTINGS."
JMB: "NO. OUR HOUSE HAD THE SAME PRINTS YOU
FIND IN EVERY AMERICAN HOUSE... NOTHING SPECIAL."

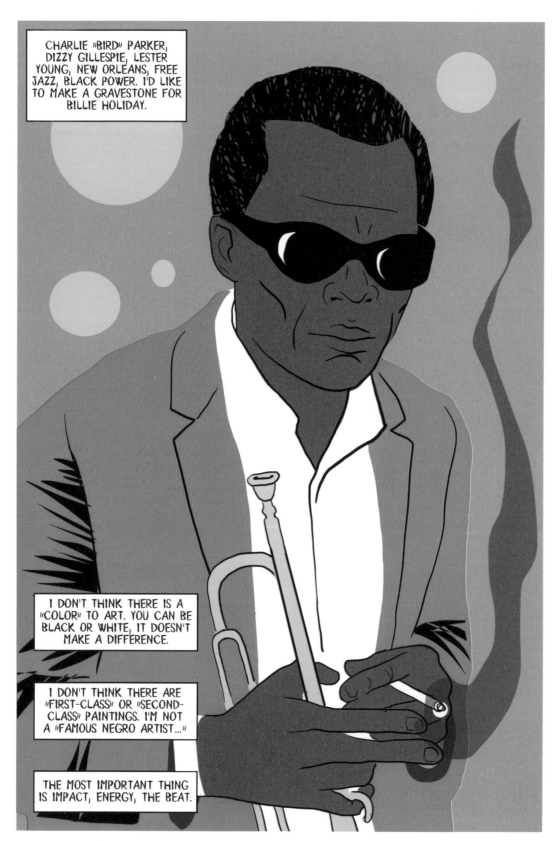

46

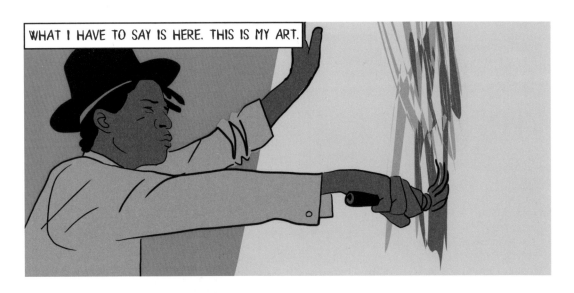

WHAT I HAVE TO SAY IS HERE. THIS IS MY ART.

I DON'T KNOW HOW TO DESCRIBE MY WORK IN ANY OTHER WAY.

IT'S LIKE ASKING MILES, "HOW DOES YOUR TRUMPET SOUND?"

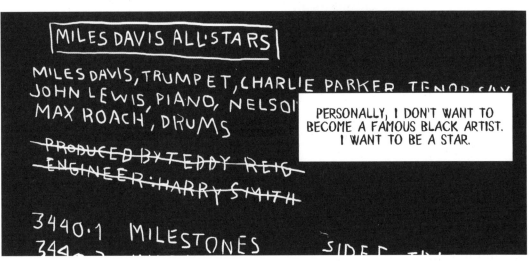

MILES DAVIS ALL STARS

MILES DAVIS, TRUMPET, CHARLIE PARKER, TENOR SAX
JOHN LEWIS, PIANO, NELSO~
MAX ROACH, DRUMS

~~PRODUCED BY TEDDY REIG~~
~~ENGINEER: HARRY SMITH~~

3440·1 MILESTONES

PERSONALLY, I DON'T WANT TO BECOME A FAMOUS BLACK ARTIST. I WANT TO BE A STAR.

THERE'S ONLY ONE WAY OF DOING IT; THE BEST, THE MOST SIMPLE AND DIRECT.

I WANT TO WORK WITH ANDY WARHOL.

BE AS DIRECT AS I WAS WITH THE SAMO© TAGS.

BUT THE GRAFFITI WORLD ISN'T FOR ME.

THERE'S GRAFFITI AND THEN THERE'S FAB 5 FREDDY. A FEW YEARS AGO HE HAD A SHOW AT A MAJOR GALLERY IN ROME.

A RARE ATTEMPT TO BRING TOGETHER TWO DIAMETRICALLY OPPOSED WORLDS.

WHEN I WAS BROKE, I SOLD HIM A COUPLE OF MY DRAWINGS, TOO, FOR A FEW HUNDRED BUCKS.

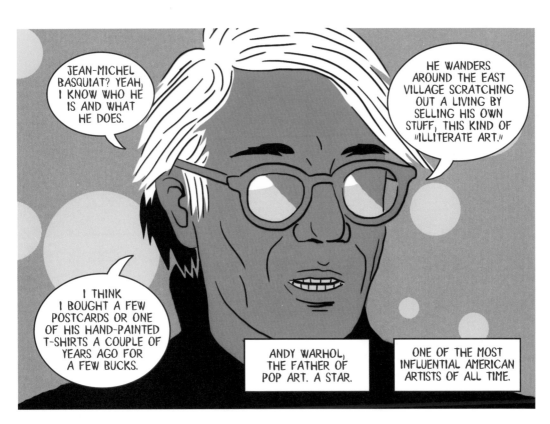

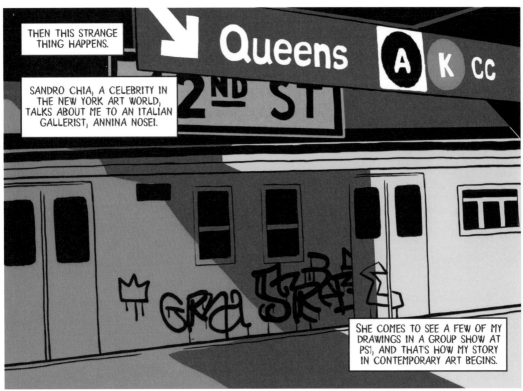

KEITH HARING (1958-1990)

JULIAN SCHNABEL (1951)

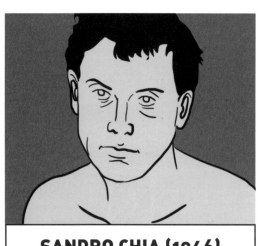

SANDRO CHIA (1946)

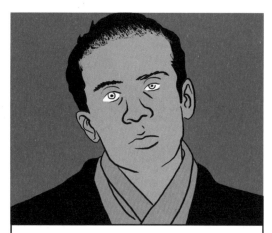

FRANCESCO CLEMENTE (1952)

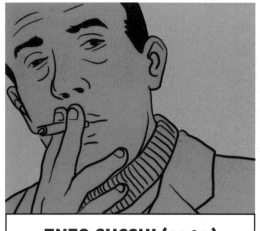

ENZO CUCCHI (1949)

MIMMO PALADINO (1948)

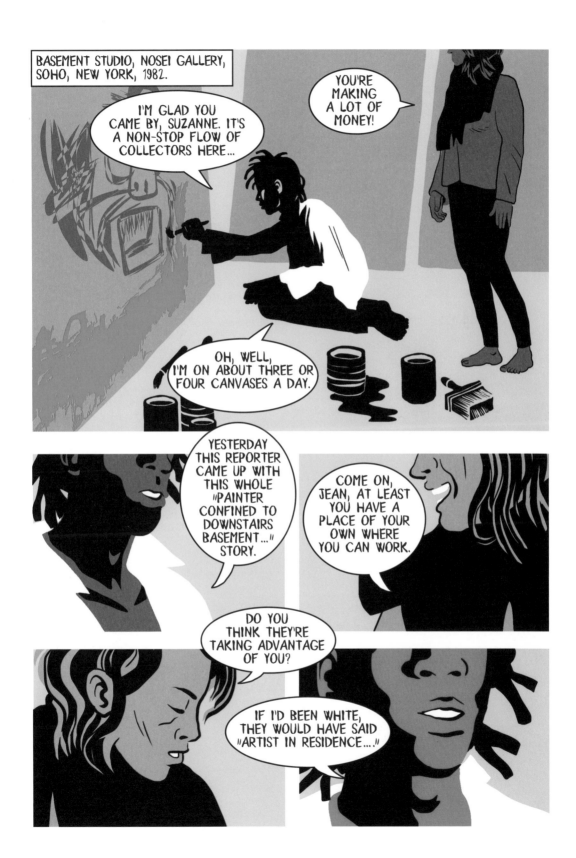

NEW ART/ NEW MONEY

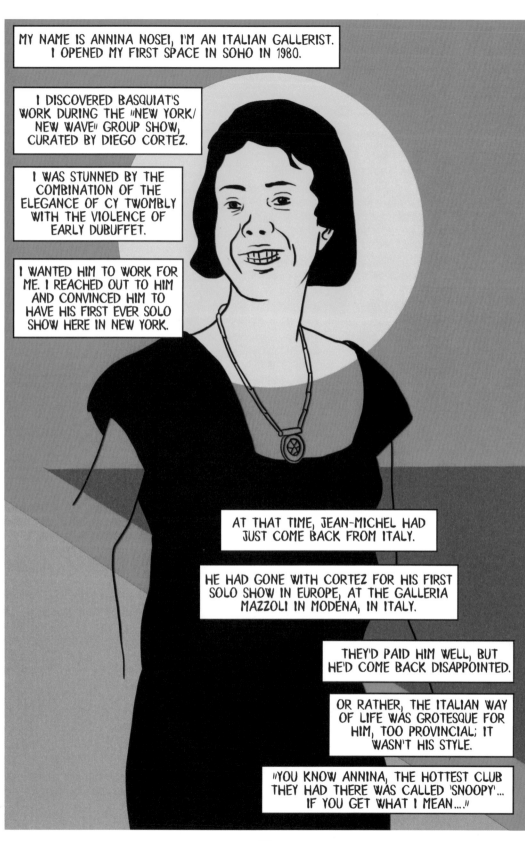

MY NAME IS ANNINA NOSEI, I'M AN ITALIAN GALLERIST. I OPENED MY FIRST SPACE IN SOHO IN 1980.

I DISCOVERED BASQUIAT'S WORK DURING THE "NEW YORK/ NEW WAVE" GROUP SHOW, CURATED BY DIEGO CORTEZ.

I WAS STUNNED BY THE COMBINATION OF THE ELEGANCE OF CY TWOMBLY WITH THE VIOLENCE OF EARLY DUBUFFET.

I WANTED HIM TO WORK FOR ME. I REACHED OUT TO HIM AND CONVINCED HIM TO HAVE HIS FIRST EVER SOLO SHOW HERE IN NEW YORK.

AT THAT TIME, JEAN-MICHEL HAD JUST COME BACK FROM ITALY.

HE HAD GONE WITH CORTEZ FOR HIS FIRST SOLO SHOW IN EUROPE, AT THE GALLERIA MAZZOLI IN MODENA, IN ITALY.

THEY'D PAID HIM WELL, BUT HE'D COME BACK DISAPPOINTED.

OR RATHER, THE ITALIAN WAY OF LIFE WAS GROTESQUE FOR HIM, TOO PROVINCIAL; IT WASN'T HIS STYLE.

"YOU KNOW ANNINA, THE HOTTEST CLUB THEY HAD THERE WAS CALLED 'SNOOPY'... IF YOU GET WHAT I MEAN...."

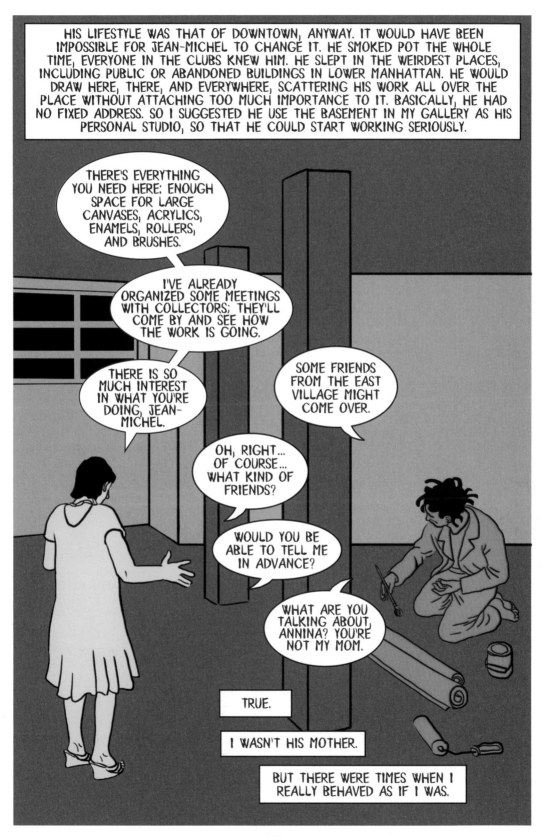

HIS LIFESTYLE WAS THAT OF DOWNTOWN, ANYWAY. IT WOULD HAVE BEEN IMPOSSIBLE FOR JEAN-MICHEL TO CHANGE IT. HE SMOKED POT THE WHOLE TIME, EVERYONE IN THE CLUBS KNEW HIM. HE SLEPT IN THE WEIRDEST PLACES, INCLUDING PUBLIC OR ABANDONED BUILDINGS IN LOWER MANHATTAN. HE WOULD DRAW HERE, THERE, AND EVERYWHERE, SCATTERING HIS WORK ALL OVER THE PLACE WITHOUT ATTACHING TOO MUCH IMPORTANCE TO IT. BASICALLY, HE HAD NO FIXED ADDRESS. SO I SUGGESTED HE USE THE BASEMENT IN MY GALLERY AS HIS PERSONAL STUDIO, SO THAT HE COULD START WORKING SERIOUSLY.

THERE'S EVERYTHING YOU NEED HERE: ENOUGH SPACE FOR LARGE CANVASES, ACRYLICS, ENAMELS, ROLLERS, AND BRUSHES.

I'VE ALREADY ORGANIZED SOME MEETINGS WITH COLLECTORS; THEY'LL COME BY AND SEE HOW THE WORK IS GOING.

THERE IS SO MUCH INTEREST IN WHAT YOU'RE DOING, JEAN-MICHEL.

SOME FRIENDS FROM THE EAST VILLAGE MIGHT COME OVER.

OH, RIGHT... OF COURSE... WHAT KIND OF FRIENDS?

WOULD YOU BE ABLE TO TELL ME IN ADVANCE?

WHAT ARE YOU TALKING ABOUT, ANNINA? YOU'RE NOT MY MOM.

TRUE.

I WASN'T HIS MOTHER.

BUT THERE WERE TIMES WHEN I REALLY BEHAVED AS IF I WAS.

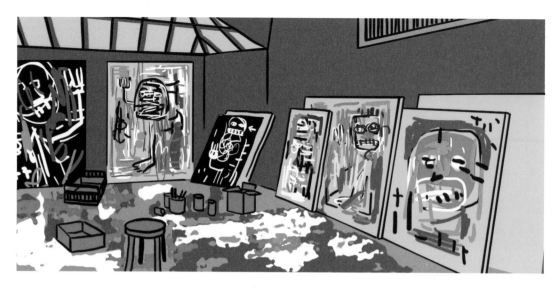

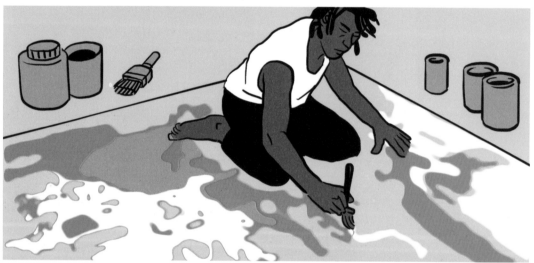

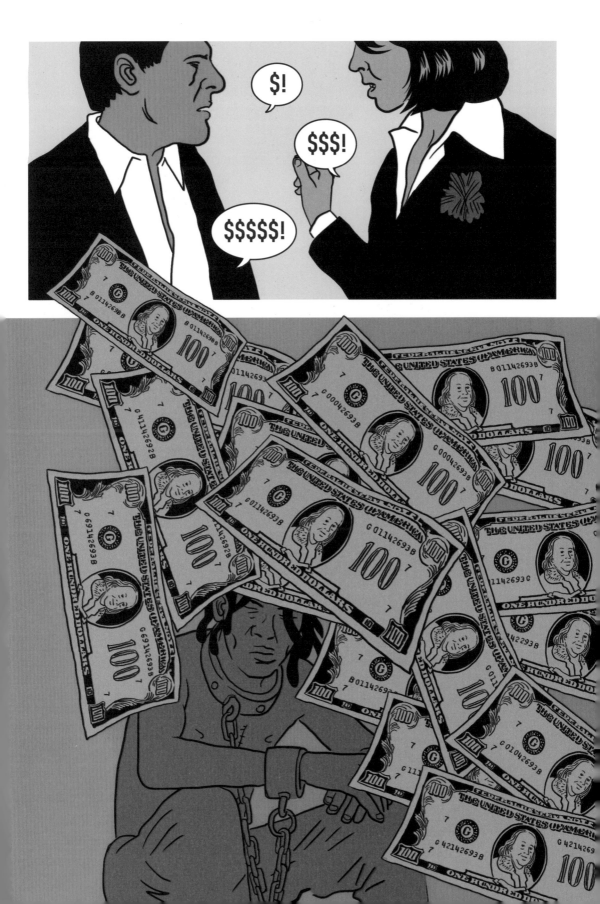

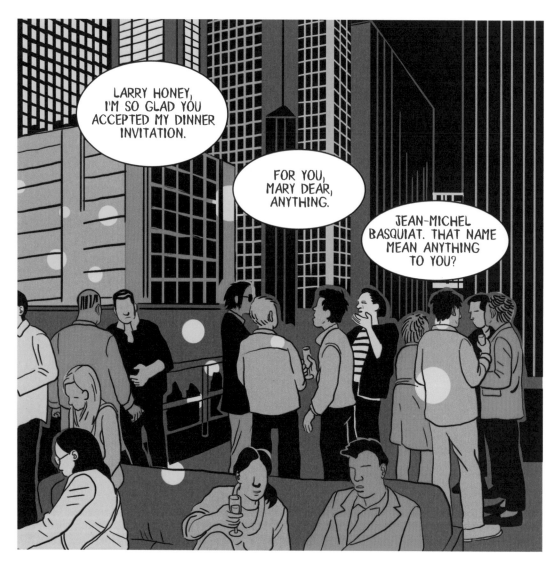

60

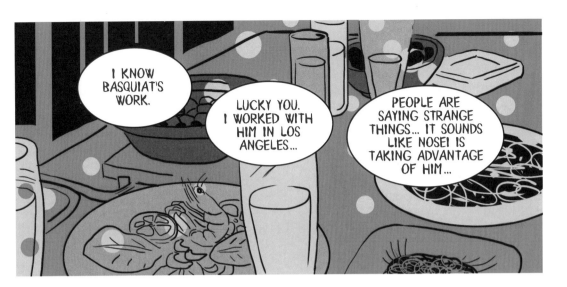

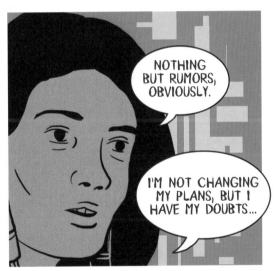

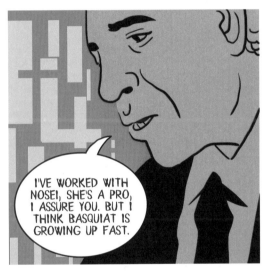

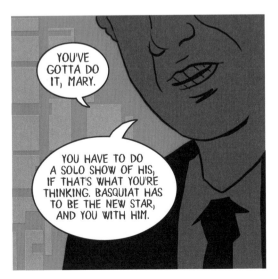

61

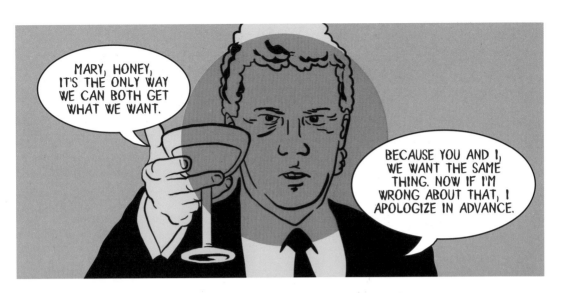

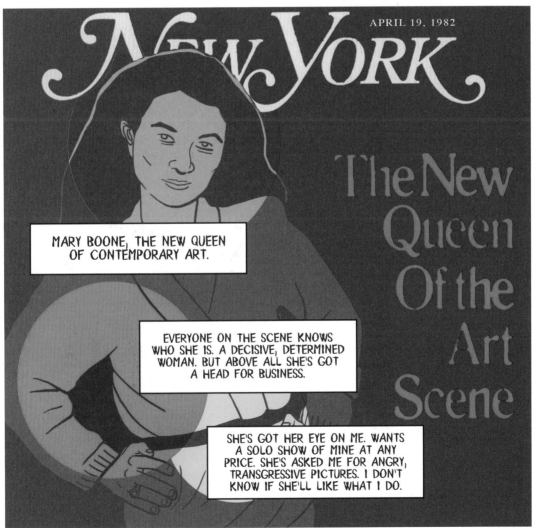

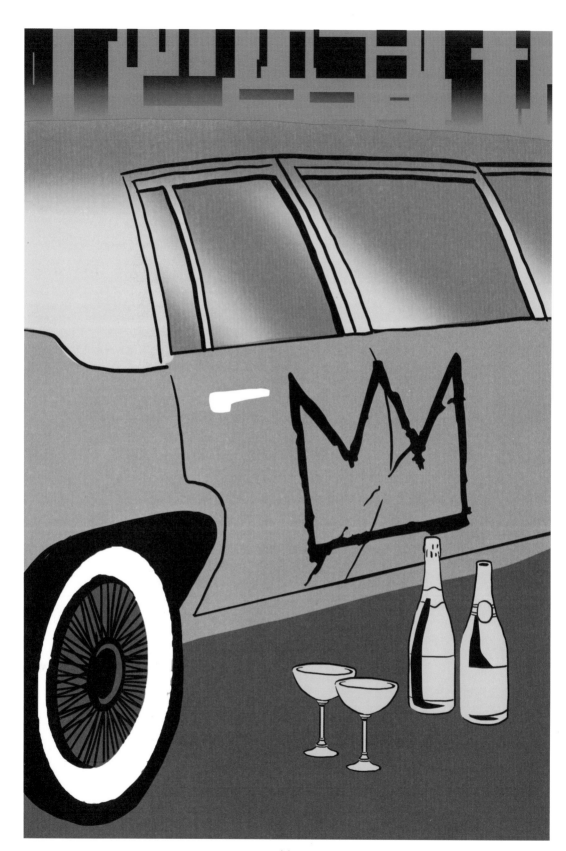

APRIL, 1984

I HAVE MONEY EVERYWHERE, EVERYWHERE. I'M PAID
EXORBITANT SUMS FOR A SINGLE PIECE.

A PICTURE I SOLD TO DEBBIE HARRY FOR $200 ONLY
A COUPLE OF YEARS AGO IS NOW WORTH $20,000.
THAT'S THE ART MARKET TODAY. WORKING WITH
GALLERY OWNERS IS EXHAUSTING.

THEY ALWAYS WANT

MORE
MORE
MORE

THERE'S SOMETHING ROTTEN IN THIS SCENE AND
I'M ONLY REALIZING IT AS TIME GOES BY.

THE MORE I GO ON, THE MORE I WANNA GIVE
UP PAINTING FOR GOOD.

MARY BOONE CALLS ME, SAYS SHE NEEDS ME FOR A PHOTO SHOOT. NOTHING TOO DEMANDING, JUST A FEW HOURS IN THE AFTERNOON. WE AGREE TO MEET AT HER GALLERY.

WHEN I ASK HER HOW SHE DID IT, SHE JUST LOOKS AT ME AND SAYS, "ALL IT TAKES IS A LITTLE EFFORT."

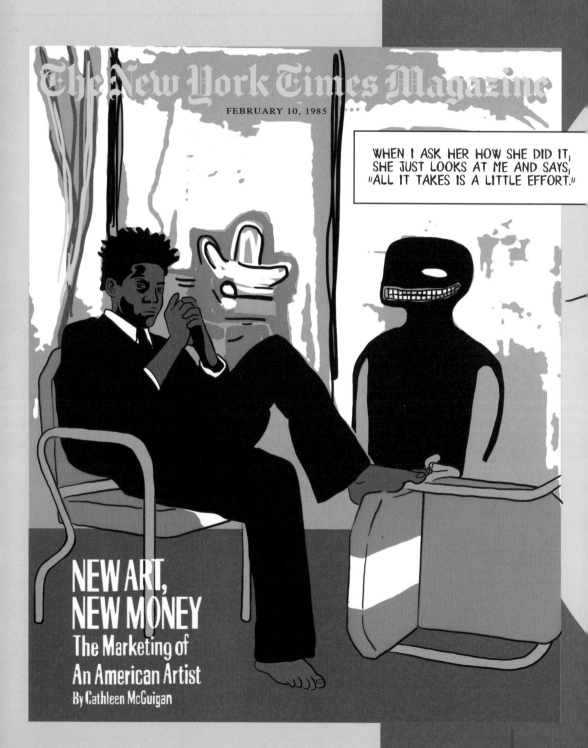

The New York Times Magazine

FEBRUARY 10, 1985

NEW ART, NEW MONEY
The Marketing of An American Artist
By Cathleen McGuigan

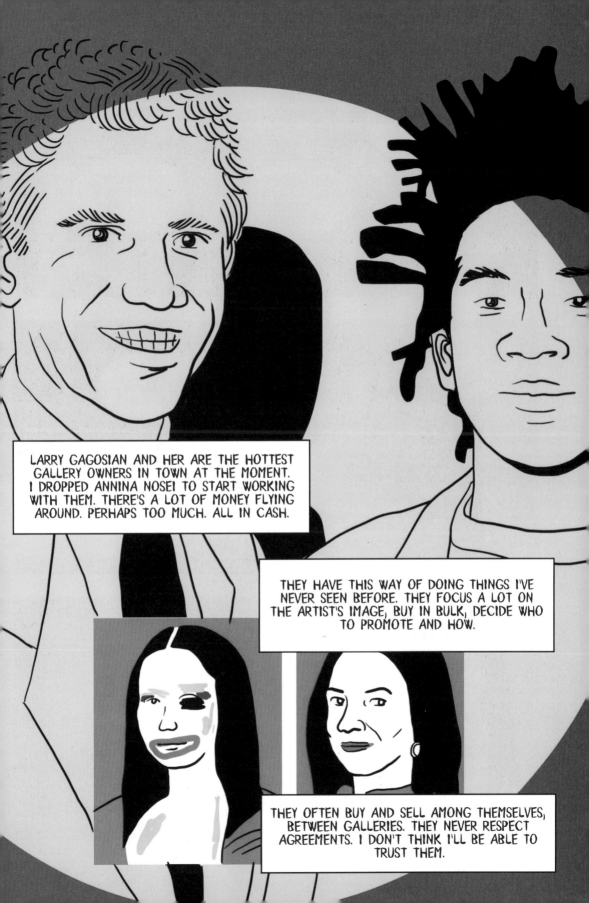

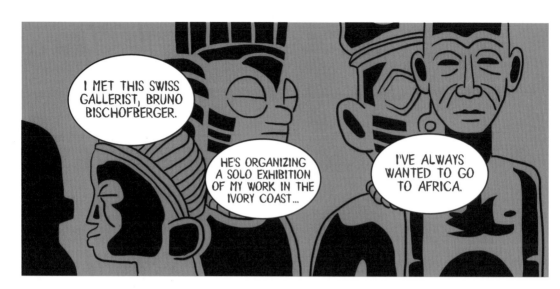

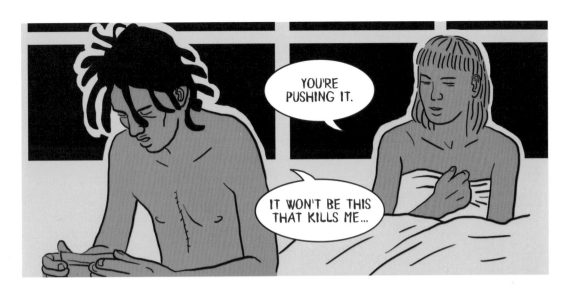

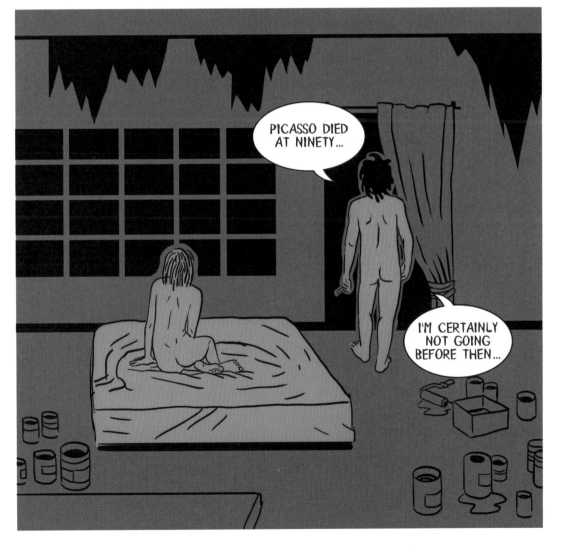

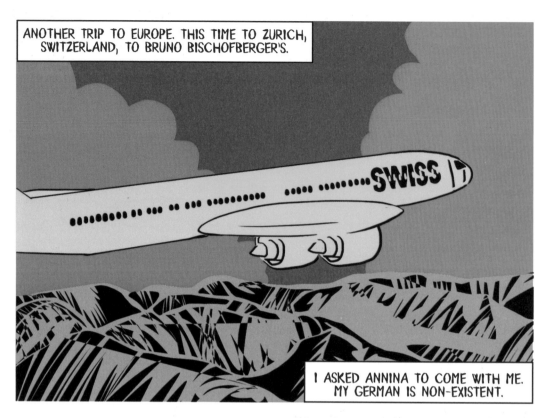

ANOTHER TRIP TO EUROPE. THIS TIME TO ZURICH, SWITZERLAND, TO BRUNO BISCHOFBERGER'S.

I ASKED ANNINA TO COME WITH ME. MY GERMAN IS NON-EXISTENT.

COME ON, ANNINA... IT'LL BE QUICK...

JEAN! PLEASE!

PUT THAT STUFF AWAY!

I THOUGHT YOU COULD IN FIRST CLASS...

BISCHOFBERGER IS ORGANIZING THIS SERIES OF MEETINGS AT HIS HOUSE IN ZURICH. MEETINGS OR "COLLABORATIONS" BETWEEN ARTISTS. WHILE I'M HERE, I'LL BE HAVING A FEW MEETINGS WITH WARHOL AND FRANCESCO CLEMENTE.

I HAVEN'T SEEN PENS LIKE THIS FOR A LONG TIME...

YEARS AGO, I USED THEM ALL THE TIME...

WHAT'S YOUR NAME?

JEAN-MICHEL.

I'M CORA.

SHALL WE DRAW SOMETHING TOGETHER?

GREAT IDEA! WHY NOT?

YOU'RE FUN, CORA.

YOU TOO!

71

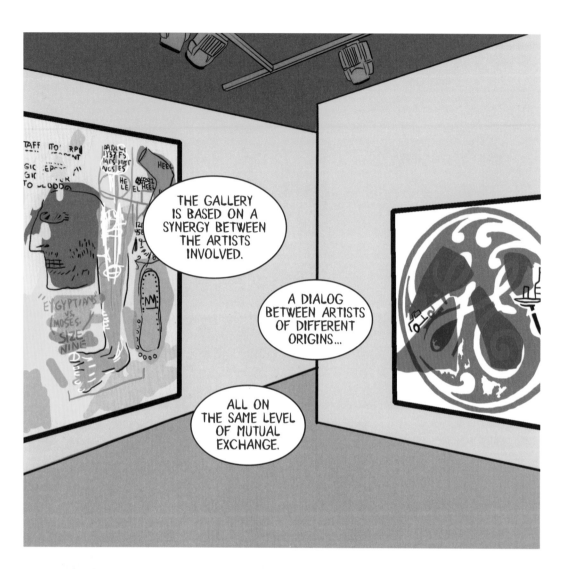

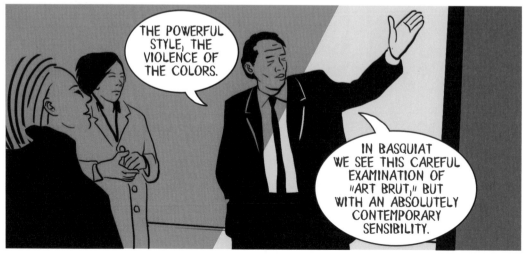

EXCELLENT. I'VE ONLY EVER FELT SOMETHING SIMILAR IN FRONT OF A DUBUFFET PAINTING.

OH... WELL... I WOULDN'T KNOW ABOUT THAT...

STRIKING AND SUBLIME AT THE SAME TIME.

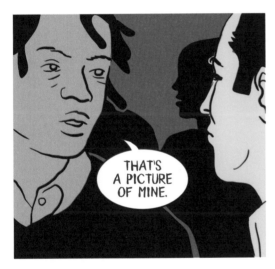

THAT'S A PICTURE OF MINE.

WELL... OF COURSE... OF THAT I HAD NO DOUBT, HERR BASQUIAT...

THIS IS MY ART.

IT'S MY LIFE.

ANDY
WARHOL

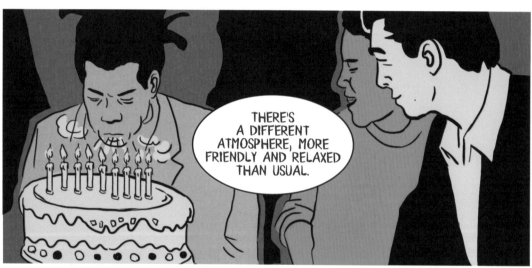

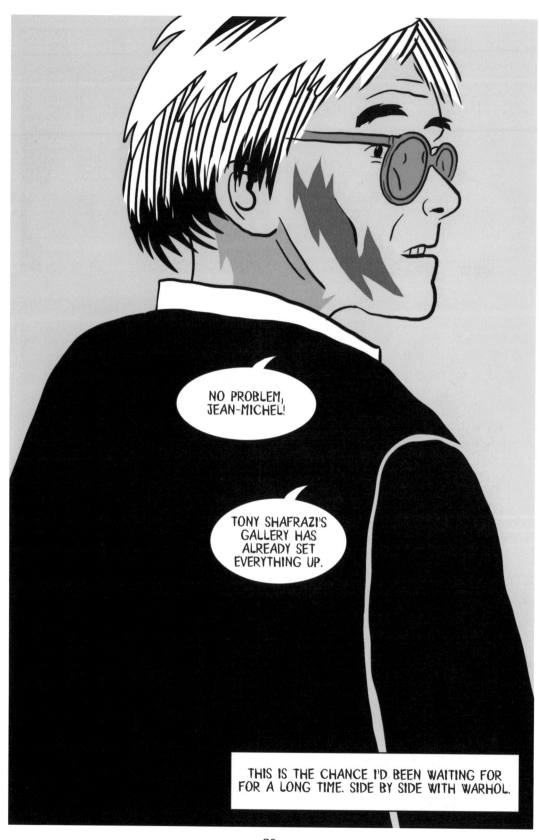

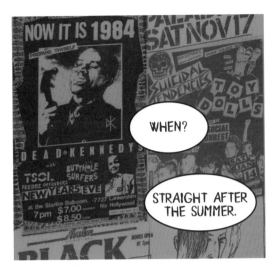

WHEN?

STRAIGHT AFTER THE SUMMER.

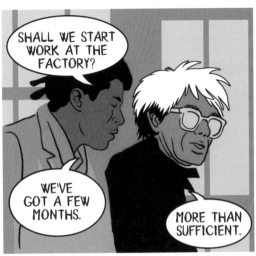

SHALL WE START WORK AT THE FACTORY?

WE'VE GOT A FEW MONTHS.

MORE THAN SUFFICIENT.

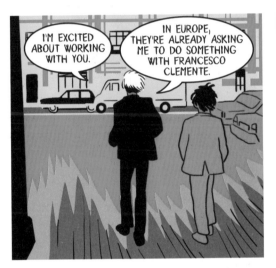

I'M EXCITED ABOUT WORKING WITH YOU.

IN EUROPE, THEY'RE ALREADY ASKING ME TO DO SOMETHING WITH FRANCESCO CLEMENTE.

THEY'RE A LOVELY IDEA, THESE COLLABORATIONS.

OUR WORLD MAKES US ACCUSTOMED TO SOLITUDE.

BUT YOU NEVER REALLY KNOW IT UNTIL YOU TASTE IT FOR YOURSELF.

DON'T YOU THINK, JEAN-MICHEL?

79

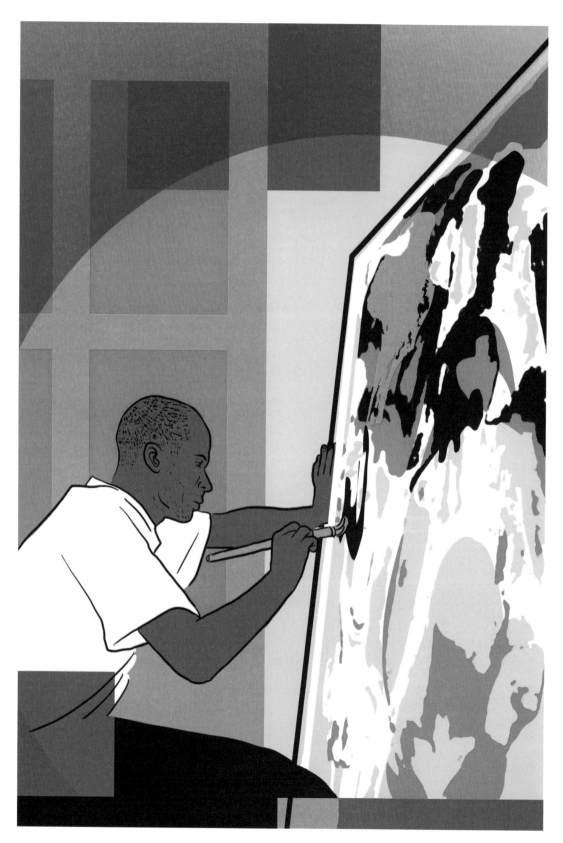

JANUARY, 1985

SAW SUZANNE TODAY.
SHE TOLD ME THAT LAST WEEK SHE MET FRANCESCO
CLEMENTE IN A CLUB. SHE ASKED HIM TO DO A
PORTRAIT OF HER, BUT SHE DIDN'T HAVE ENOUGH
MONEY TO PAY HIM.

HE DID IT FOR HER ANYWAY. THEY MET AT HIS STUDIO.

 HOW IS THAT POSSIBLE?
 I WENT CRAZY.
 I'M ANGRY AND DEPRESSED.

 I'M A BETTER PAINTER THAN CLEMENTE...

 SHE SAID THAT'S TRUE, I AM A BETTER PAINTER,
 BUT SHE STILL WANTED TO ASK CLEMENTE.

 I DON'T KNOW IF I WANT TO SEE HER AGAIN.
 I DEFINITELY DON'T WANT TO SEE THE PORTRAIT.

 ANDY ASKED ME WHY I WAS SO ON EDGE TODAY.
 I DIDN'T KNOW WHAT TO PAINT AND SO HE SAID:
 "PAINT SOME FIRE."

 I WENT TO CLEMENTE'S STUDIO AND SET FIRE TO
 THE PORTRAITS OF SUZANNE.

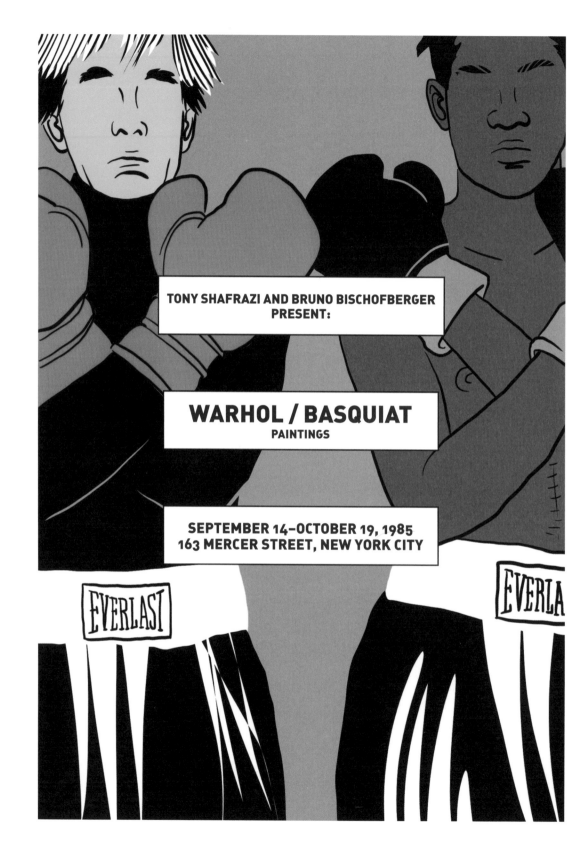

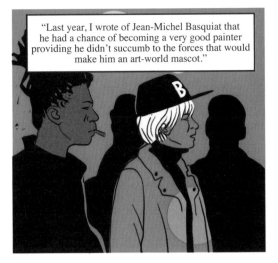

"Last year, I wrote of Jean-Michel Basquiat that he had a chance of becoming a very good painter providing he didn't succumb to the forces that would make him an art-world mascot."

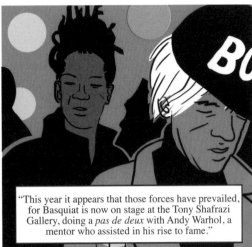

"This year it appears that those forces have prevailed, for Basquiat is now on stage at the Tony Shafrazi Gallery, doing a *pas de deux* with Andy Warhol, a mentor who assisted in his rise to fame."

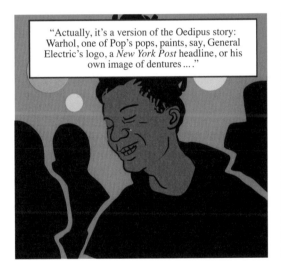

"Actually, it's a version of the Oedipus story: Warhol, one of Pop's pops, paints, say, General Electric's logo, a *New York Post* headline, or his own image of dentures"

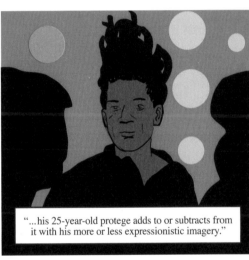

"...his 25-year-old protege adds to or subtracts from it with his more or less expressionistic imagery."

"The collaboration looks like one of Warhol's many manipulations"

" ... it seems to articulate one of those theories according to which nobody loses out by underestimating the public's intelligence."

"Basquiat, meanwhile, comes across as the all-too-willing accessory. In the same spirit as the show's poster, the verdict is: "Warhol, TKO in 16 rounds."

Vivien Raynor,
New York Times,
September 20, 1985

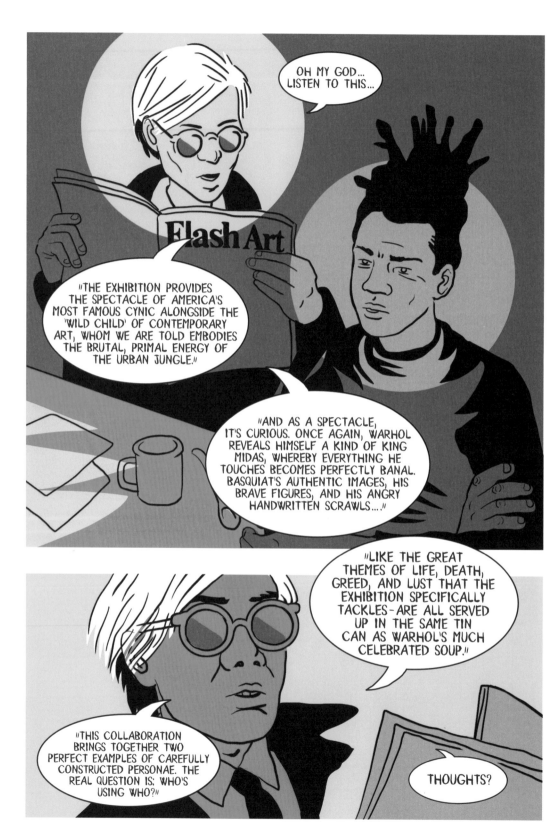

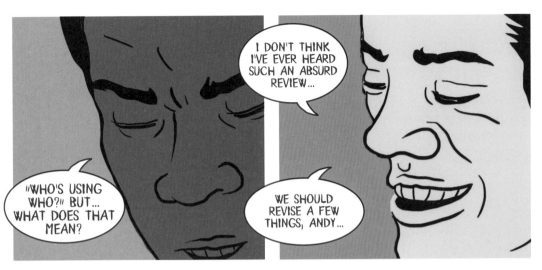

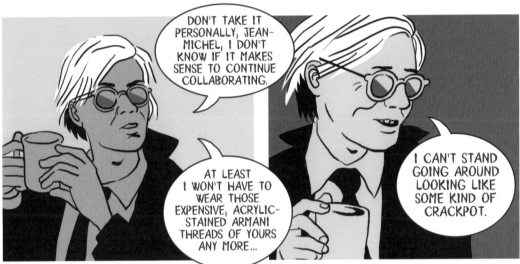

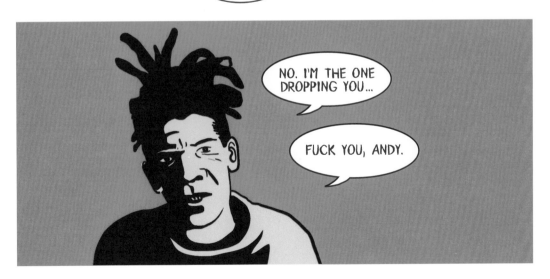

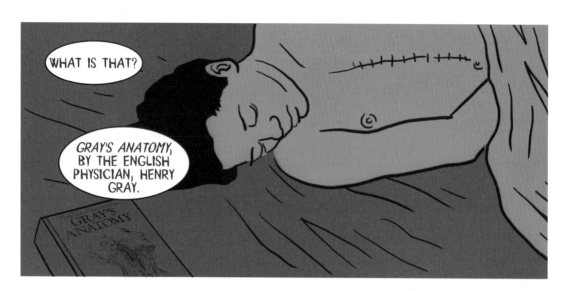

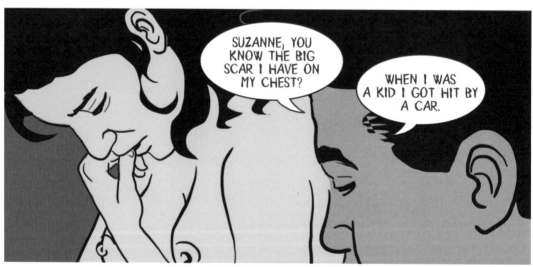

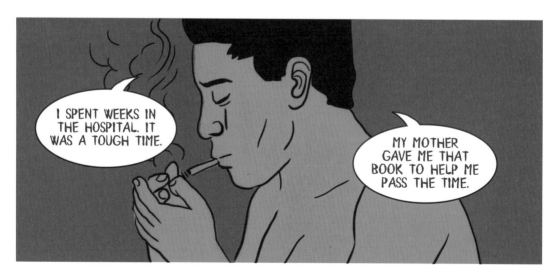

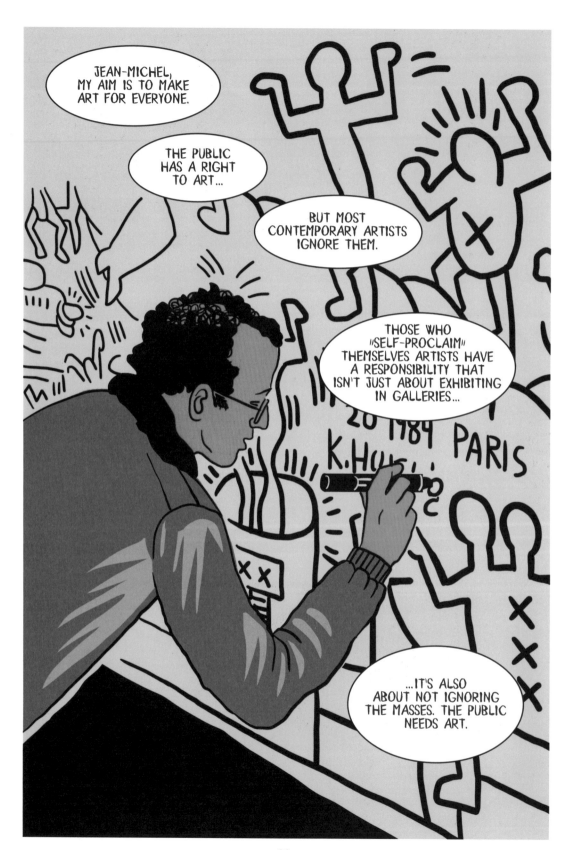

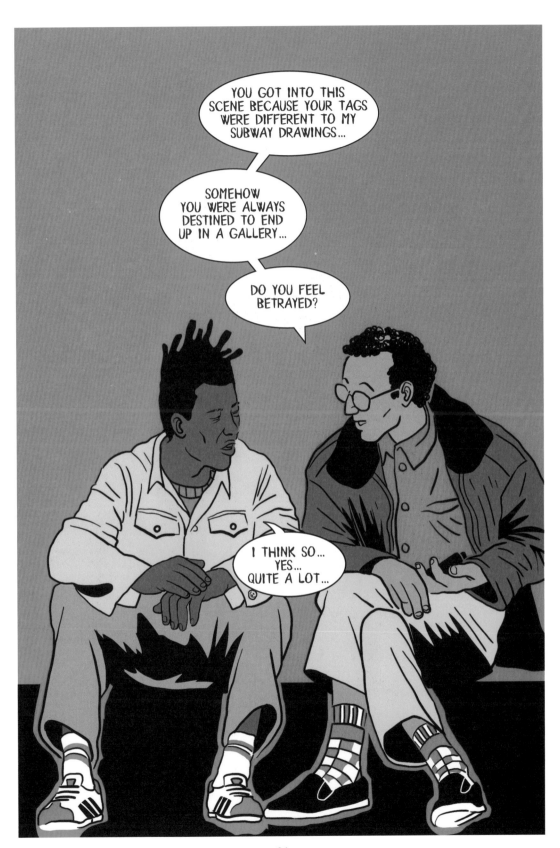

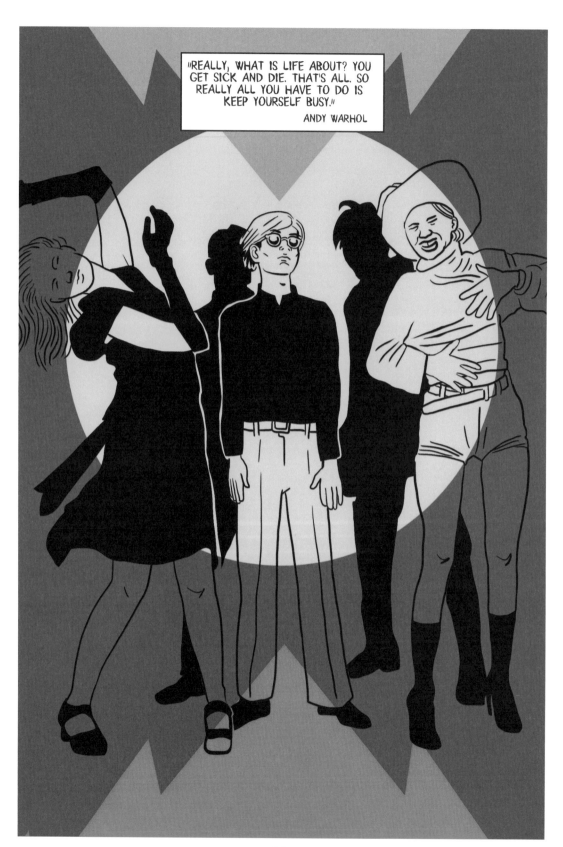

"REALLY, WHAT IS LIFE ABOUT? YOU GET SICK AND DIE. THAT'S ALL. SO REALLY ALL YOU HAVE TO DO IS KEEP YOURSELF BUSY."

ANDY WARHOL

FEBRUARY, 1987

IT WAS FUN BEING WITH HIM. WORKING SIDE BY SIDE. HE
ALWAYS HAD SOME CRAZY STORY TO TELL YOU. IT
SEEMED LIKE HE KNEW EVERYTHING ABOUT EVERYBODY.
WE WERE HIGH ON SPEED THE WHOLE TIME.

~~YOU ALWAYS LEARNED~~ SOMETHING JUST BY LOOKING
HIM STRAIGHT IN THE EYE.

ANDY'S DEAD.

I FEEL MORE ALONE. NOW ~~I~~

 I DON'T WANT TO ~~WRITE~~ ANY MORE.

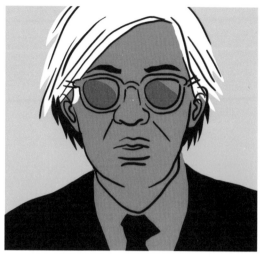

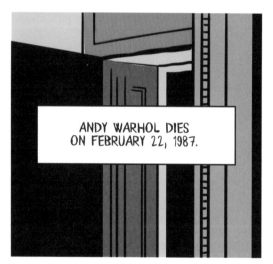

ANDY WARHOL DIES ON FEBRUARY 22, 1987.

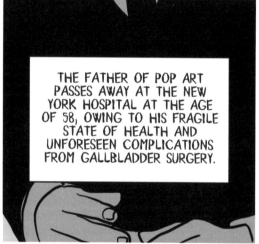

THE FATHER OF POP ART PASSES AWAY AT THE NEW YORK HOSPITAL AT THE AGE OF 58, OWING TO HIS FRAGILE STATE OF HEALTH AND UNFORESEEN COMPLICATIONS FROM GALLBLADDER SURGERY.

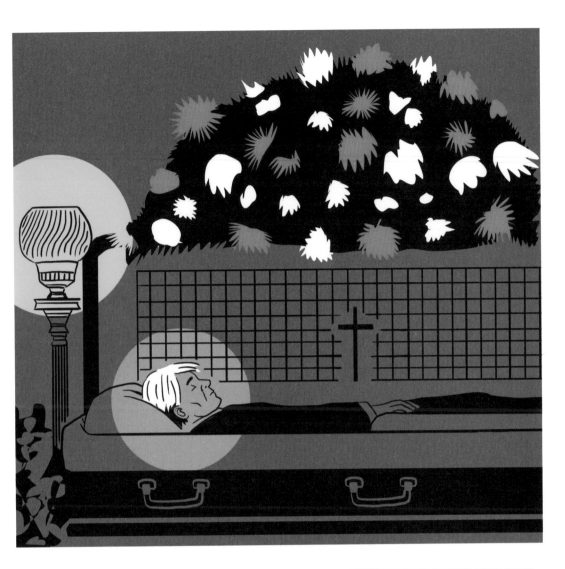

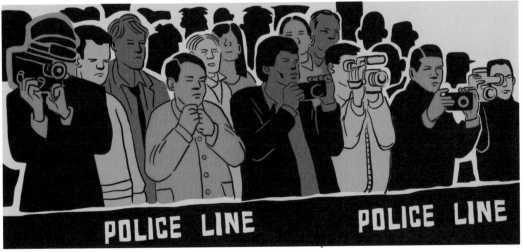

POLICE LINE POLICE LINE

RIDING
WITH
DEATH

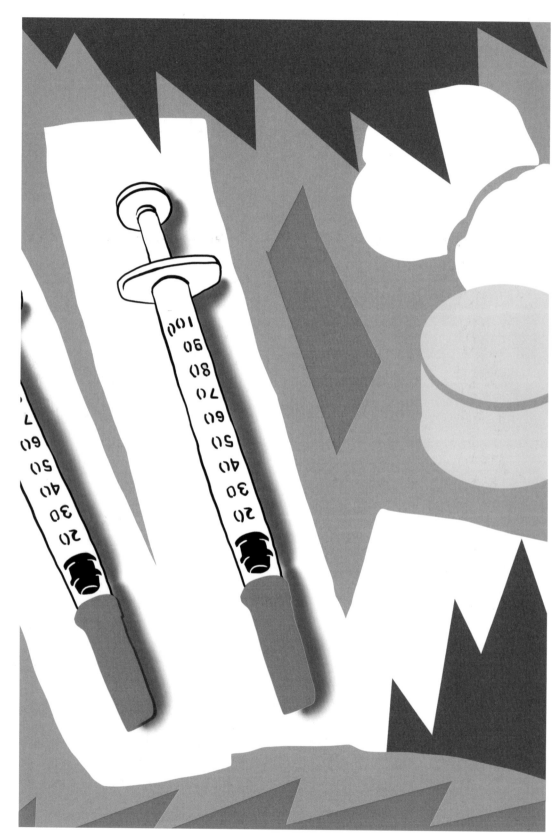

SEPTEMBER, 1987

I ORDERED TEN BOXES OF ITALIAN PASTRIES
FROM DEAN AND DELUCA.
I WASN'T HUNGRY SO THEY JUST STAYED THERE,
ON THE BIG TABLE IN THE LIVING ROOM.

IT HAPPENS A LOT. I BUY STUFF AND THROW IT OUT.
I NEVER CONSUME.

THERE ARE SOME THINGS
I'VE GOTTA QUIT.

IF I WANT TO KEEP PAINTING.

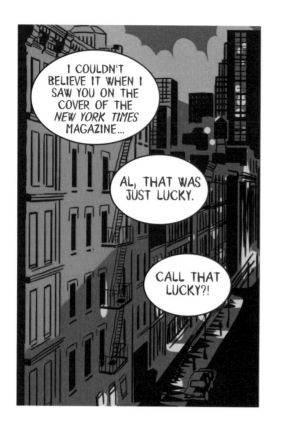

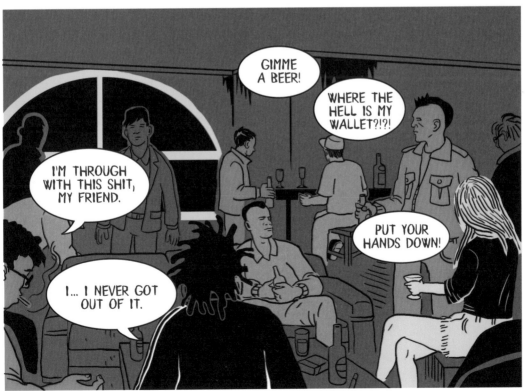

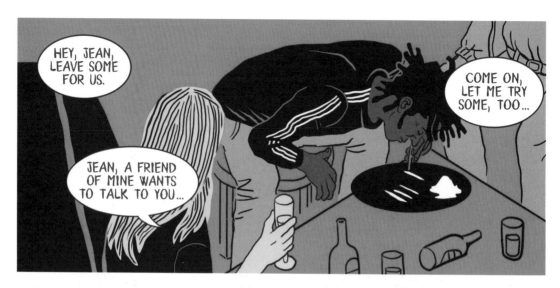

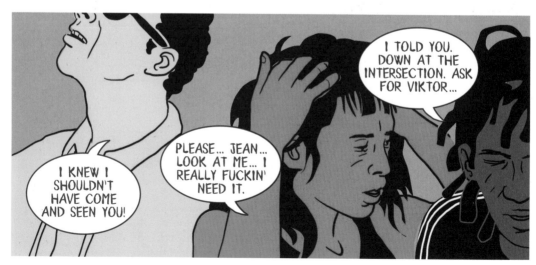

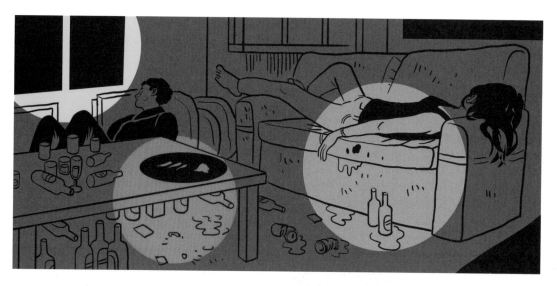

I... I...
FEEL SICK...

MY HEAD'S
POUNDING.

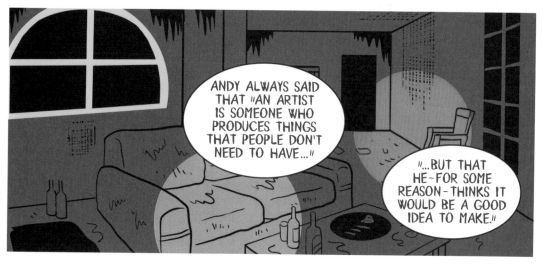

ANDY ALWAYS SAID
THAT "AN ARTIST
IS SOMEONE WHO
PRODUCES THINGS
THAT PEOPLE DON'T
NEED TO HAVE..."

"...BUT THAT
HE-FOR SOME
REASON-THINKS IT
WOULD BE A GOOD
IDEA TO MAKE."

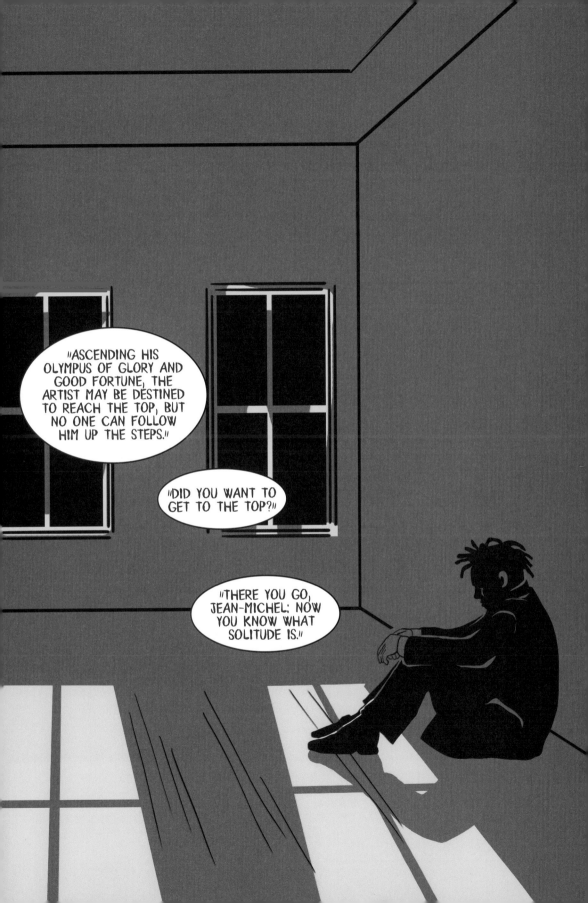

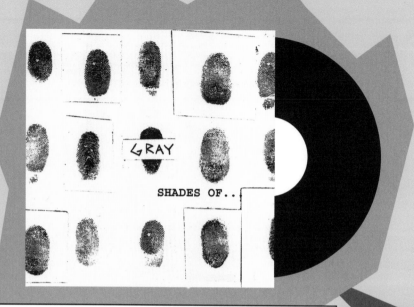

TODAY I LISTENED TO SOME OLD TRACKS BY MY BAND, GRAY. I STARTED IT WITH THE PERFORMER AND MUSICIAN MICHAEL HOLMAN IN 1979. THERE WERE GUYS LIKE VINCENT GALLO AND SHANNON DAWSON WITH US, TOO.

WE PLAYED THIS WONDERFUL, JARRING STUFF. SOMETHING LIKE ART PUNK? IF EVER ART PUNK EXISTED...

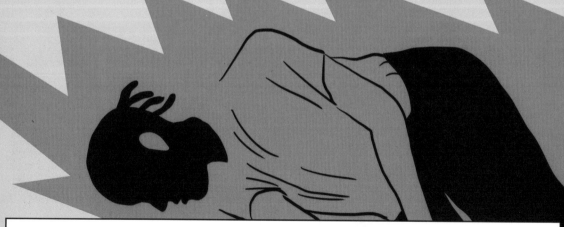

ONE OF MY FAVORITE TRACKS IS "SUICIDE HOTLINE" FROM 1980. JUSTIN THYME HAD RECORDED ME WHILE I WAS ON THE PHONE TO A FREEPHONE SUICIDE PREVENTION HOTLINE. THE WHOLE CONVERSATION WAS A GAME BETWEEN ME AND THE OPERATOR: I READ FRAGMENTS OF POETRY IN THIS INSISTENT, DRAMATIC VOICE; HE DOESN'T KNOW IF HE'S TALKING TO A SUICIDAL MANIAC OR SOME CRAZY GUY MAKING FUN OF HIM. WE PUT THE RESULT AGAINST A BACKGROUND OF DISSONANT NOISE.

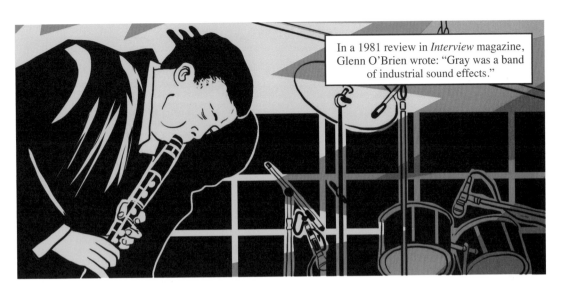

In a 1981 review in *Interview* magazine, Glenn O'Brien wrote: "Gray was a band of industrial sound effects."

NOISE
NO WAVE

"They really developed their own original groove."

"A mix of easy listening, bebop, noise, and lounge."

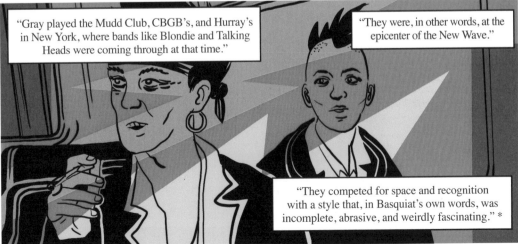

"Gray played the Mudd Club, CBGB's, and Hurray's in New York, where bands like Blondie and Talking Heads were coming through at that time."

"They were, in other words, at the epicenter of the New Wave."

"They competed for space and recognition with a style that, in Basquiat's own words, was incomplete, abrasive, and weirdly fascinating." *

*ROBERT FARRIS THOMPSON (ANTHROPOLOGY PROFESSOR AT YALE) IN HIS INTRODUCTION TO THE CATALOG FOR THE BASQUIAT RETROSPECTIVE AT THE WHITNEY MUSEUM IN NEW YORK, 1991.

OK, GUYS, WE NEED TO BE FAST AND PRECISE.

JEAN, LET'S DO A SCENE BEFORE A COP CAR SHOWS UP...

MY NAME IS EDO BERTOGLIO, I'M A PHOTOGRAPHER AND DIRECTOR. IT'S 1980 AND WE'RE SHOOTING SCENES FOR *NEW YORK BEAT*.

THE BUDGET'S REALLY TIGHT, AND WE'RE NOT REALLY PROFESSIONALS.

PLUS, THE RECENT "ANTI-GRAFFITI" ORDER FORCES US TO WORK IN SEMI-CLANDESTINITY.

THE SCENES IN WHICH THE MAIN CHARACTER WRITES ON THE WALLS NEED TO BE SHOT AS DISCRETELY AS POSSIBLE. IF WE GET CAUGHT "IN THE ACT" BY THE COPS, THEY'LL CONFISCATE ALL THE EQUIPMENT AND WE CAN KISS GOODBYE TO THE MOVIE.

THE SCREENPLAY, WRITTEN BY GLENN O'BRIEN, GOES MORE OR LESS LIKE THIS: IT'S THE STORY OF AN ARTIST WHO LIVES HAND TO MOUTH, WITH NO MONEY OR FIXED ADDRESS.

HE COMES OUT OF A HOSPITAL WITH A CLARINET IN HIS HANDS AND MEETS A GIRL. THE WHOLE MOVIE TAKES PLACE OVER 24 HOURS, DURING WHICH TIME OUR BOHEMIAN PROTAGONIST SEARCHES THE WHOLE OF DOWNTOWN FOR HER.

AMID THE DRUG DEALERS, HOOKERS, NIGHT CLUBS, MUSICIANS, AND LOUSY PAINTERS, OUR PROTAGONIST FINALLY MANAGES TO FIND HIS MUSE AND KISS HER PASSIONATELY.

IT'S A SORT OF "UNDERGROUND FAIRYTALE" AND JEAN FITS THE LEAD ROLE LIKE A GLOVE.

WE ALL MAKE ABOUT $400 A WEEK. JEAN MAKES ABOUT HALF THAT. NOTHING COMPARED TO WHAT PROFESSIONAL ACTORS AND CREW REALLY MAKE.

BUT THEN, IT'S NOT A PROBLEM FOR HIM. YESTERDAY I FOUND OUT HE'D MANAGED TO SELL A FEW DRAWINGS TO PEOPLE IN THE TEAM.

WE'RE TALKING ABOUT A FAIR SUM OF MONEY, A FEW HUNDRED DOLLARS. SO LET'S JUST SAY HE MANAGES TO MAKE ENDS MEET.

I'VE MANAGED TO CONVINCE EVERYONE TO BE INVOLVED: PEOPLE LIKE DEBBIE HARRY, FAB 5 FREDDY, AND BANDS LIKE PLASTICS AND DNA.

IT'S A MOVIE WE ALL REALLY CARE ABOUT.

I DON'T KNOW WHEN WE'LL BE ABLE TO FINISH SHOOTING.

OCTOBER, 1987

I CALLED EDO BERTOGLIO TODAY.
AFTER ALL THIS TIME, NEW YORK BEAT STILL ISN'T
AT THE EDITING STAGE.

ALL THE MATERIAL IS THERE. AND THE SOUNDTRACK.

THERE'S NO MONEY. OVER THE YEARS ALL THE
PEOPLE INVOLVED HAVE GONE ON TO NEW PROJECTS,
THE MOVIE HAS HAD HUNDREDS OF PROBLEMS.
IT FEELS LIKE THE END OF A CHAPTER.

MAYBE IT REALLY IS.

MAUI, 1988.

THE SECOND IN THE ARCHIPELAGO OF HAWAIIAN ISLANDS.

HAWAIIAN GOVERNMENT SURVEY

MAUI
HAWAIIAN ISLANDS.

I'VE RENTED A RANCH. I'M GOING TO STAY HERE FOR A WHILE... TO READ AND PAINT. I FEEL THE NEED TO TAKE BACK CONTROL OF MY OWN LIFE. I FEEL COMFORTABLE AMID THESE DENSE GREEN VALLEYS AND THE VOLCANIC ROCKS AS BLACK AS COAL. EVERYTHING IS UNTOUCHED...

IN THE MORNING I GO TO THE SEVEN SACRED POOLS, THESE NATURAL WATERFALLS A FEW KILOMETERS FROM THE RANCH, AND STAY THERE UNTIL SUNSET. I TRY AND APPRECIATE MOMENTS I NEVER GET TO LIVE IN NEW YORK. I'VE MET A FEW PEOPLE FROM THE ISLAND. LAST NIGHT I WAS OVER AT MIKE'S PLACE. HE ALSO RAN AWAY FROM NEW YORK MORE THAN TEN YEARS AGO TO SEEK REFUGE IN THIS LITTLE PARADISE. I'M EXPECTING SUZANNE AND MY SISTER IN THE NEXT FEW DAYS, AND MAYBE MY FATHER GERARD.

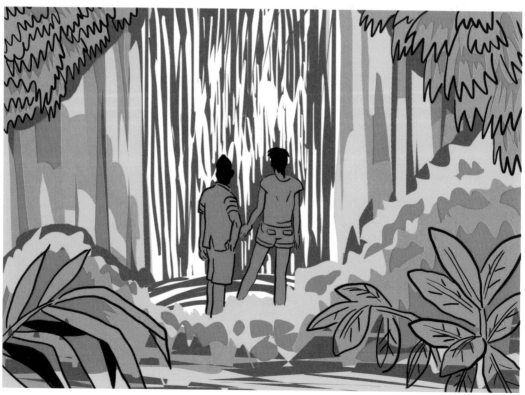

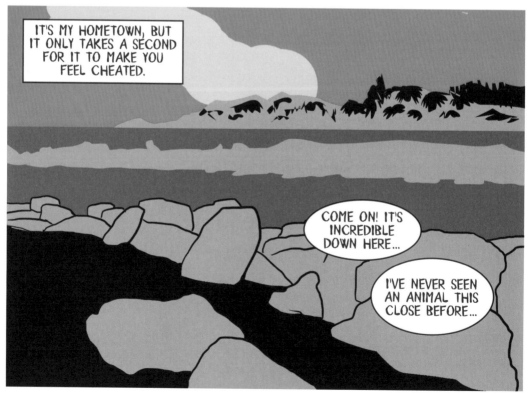

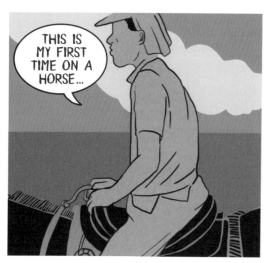

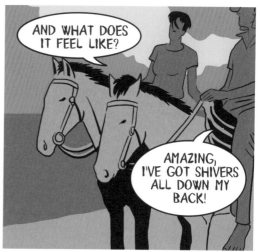

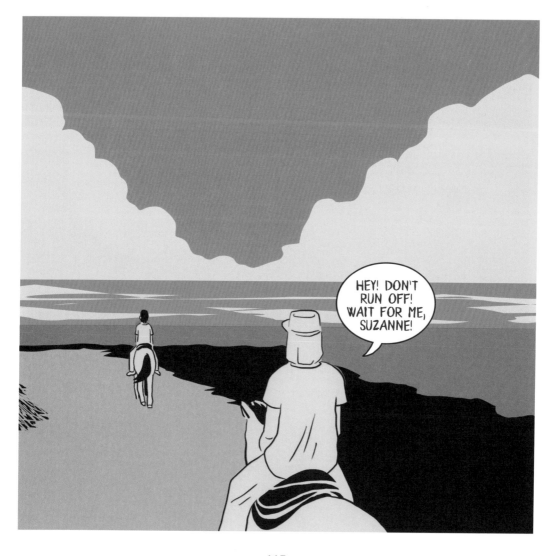

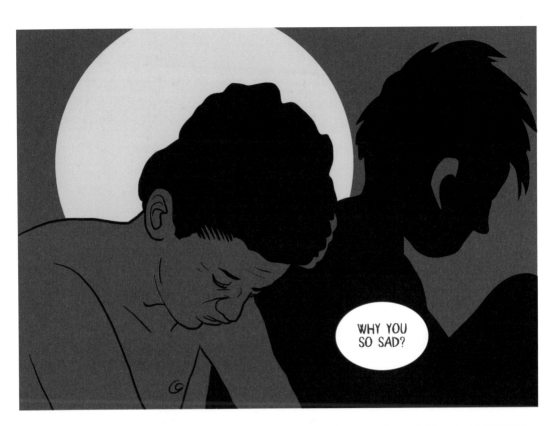

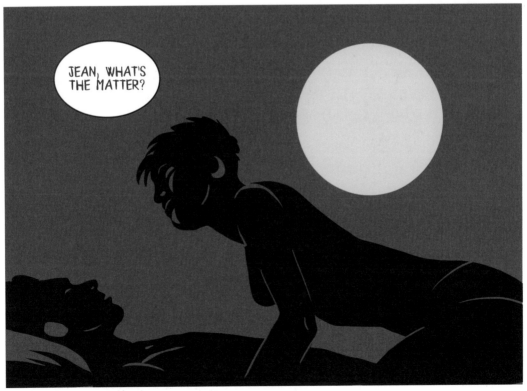

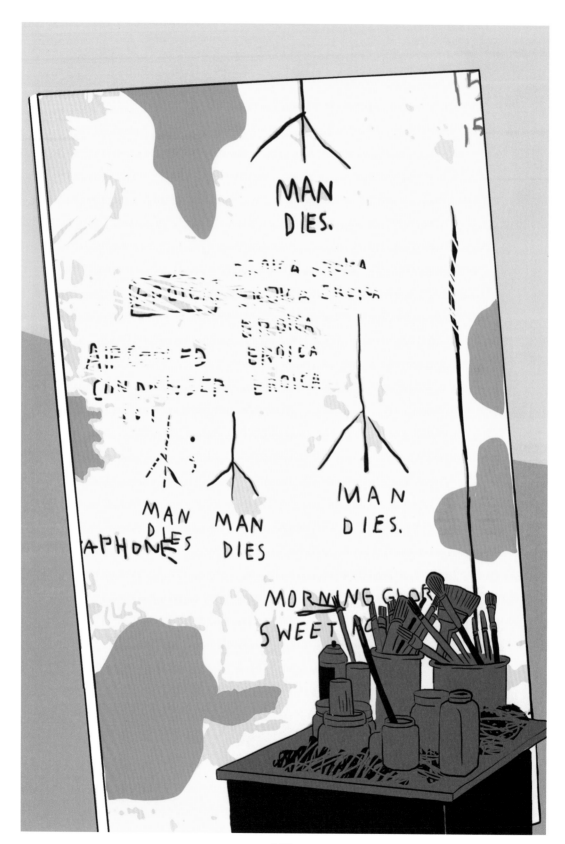

MARCH, 1988

I'VE DONE SOME NEW PICTURES. I HAVEN'T SHOWN
ANYTHING IN THE CITY FOR A YEAR AND A HALF. I
WAS IN FRANCE, BUT IT WAS A BIT OF A FAILURE.
I WAS OFFERED A SHOW FOR ONE NIGHT IN THE
EAST VILLAGE.
I SAID YES.

I'M FINDING IT DIFFICULT TO PAINT. I CAN'T STAY
SAT ON THE STOOL. I NEED A BREAK.

I'VE BEEN LISTENING TO A LOT OF BEETHOVEN
RECENTLY. I CALLED THE FIRST TWO CANVASES
EROICA I AND EROICA II.
THE PHRASE, "MAN DIES" KEEPS COMING BACK.
MAYBE IT'S INTENTIONAL.
I WROTE IT ON IMPULSE, WITHOUT THINKING.

THE THIRD ONE IS ON LEONARDO DA VINCI.
RIDING WITH DEATH. A HORSEMAN RIDING A
SKELETON. NOTHING ELSE.

GALLOPING WITH DEATH, A MAN DIES.

"MAN DIES"
"MAN DIES" "MAN DIES"
"MAN DIES"

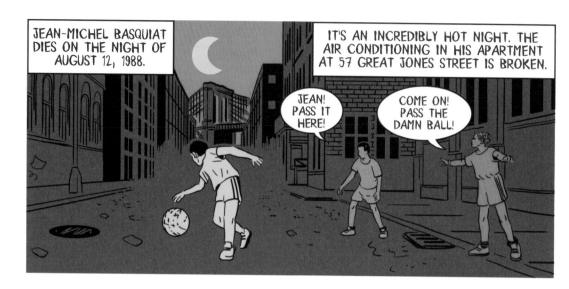

JEAN-MICHEL BASQUIAT DIES ON THE NIGHT OF AUGUST 12, 1988.

IT'S AN INCREDIBLY HOT NIGHT. THE AIR CONDITIONING IN HIS APARTMENT AT 57 GREAT JONES STREET IS BROKEN.

JEAN! PASS IT HERE!

COME ON! PASS THE DAMN BALL!

HE'S ASLEEP UPSTAIRS. THAT NIGHT—A FRIDAY—HE HAD AGREED TO GO TO A CONCERT.

JEAN! IT'S GETTING DARK. WATCH OUT FOR THE CARS!

HE DOESN'T FEEL WELL, TRIES TO GET TO THE BATHTUB. FEELS VERY SICK. HE FAINTS, FALLS TO THE FLOOR.

JEAN! DID YOU HEAR ME!?

727-XMC

A FRIEND FINDS HIM LITERALLY LYING IN A POOL OF VOMIT. SHE CALLS AN AMBULANCE. IT TAKES A LONG TIME TO COME.

DAMN YOU, JEAN, GET OUT THE WAY!

GRAY'S ANATOMY - FIG. 01 - THE HEART

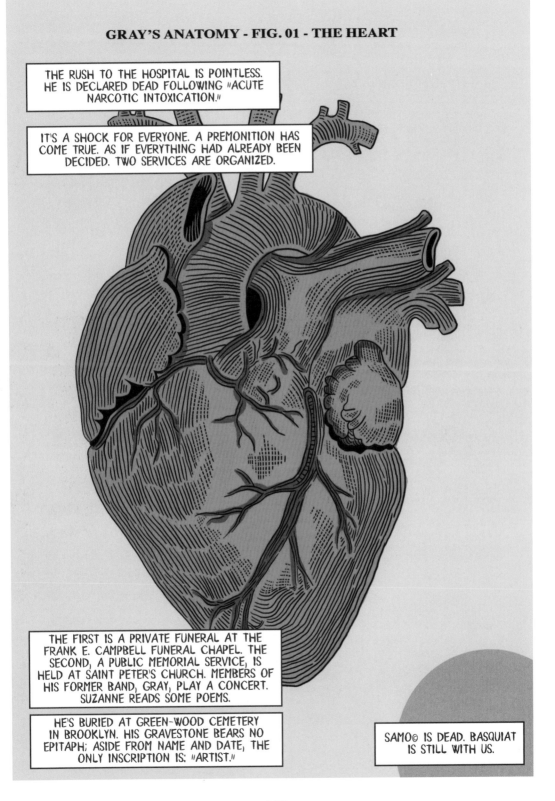

THE RUSH TO THE HOSPITAL IS POINTLESS. HE IS DECLARED DEAD FOLLOWING "ACUTE NARCOTIC INTOXICATION."

IT'S A SHOCK FOR EVERYONE. A PREMONITION HAS COME TRUE. AS IF EVERYTHING HAD ALREADY BEEN DECIDED. TWO SERVICES ARE ORGANIZED.

THE FIRST IS A PRIVATE FUNERAL AT THE FRANK E. CAMPBELL FUNERAL CHAPEL. THE SECOND, A PUBLIC MEMORIAL SERVICE, IS HELD AT SAINT PETER'S CHURCH. MEMBERS OF HIS FORMER BAND, GRAY, PLAY A CONCERT. SUZANNE READS SOME POEMS.

HE'S BURIED AT GREEN-WOOD CEMETERY IN BROOKLYN. HIS GRAVESTONE BEARS NO EPITAPH; ASIDE FROM NAME AND DATE, THE ONLY INSCRIPTION IS: "ARTIST."

SAMO© IS DEAD. BASQUIAT IS STILL WITH US.

ACKNOWLEDGMENTS

So many people made this book possible.

My thanks to all of those who, in one way or another, have put up with and supported me.

All those who met me halfway and gave me advice during the research phase.

My thanks also go, indirectly, to Phoebe Hoban and Michel Nuridsany for having written two very different but beautiful, complementary biographies, both of which are enormously rich in insights, reflections, interviews, and anecdotes. They were an inexhaustible resource, and provided the basis of some of the scenes in these pages.

My thanks to the publisher and all the staff for involving and accompanying me on this new adventure.

Direct as always, I'll grit my teeth until the next project.

BIBLIOGRAPHY

Achille Bonito Oliva, *Jean-Michel Basquiat e gli american graffiti (Jean-Michel Basquiat and American Graffiti)*, Milan, Abscondita, 2017

Francesco Clemente, *Francesco Clemente*, text by Michael Auping, Milan, Charta, c2000

Glenn O'Brien and Diego Cortez (eds), *Jean-Michel Basquiat: 1981, the Studio of the Street*, Milan, Charta, 2007

Jennifer Clement, *Widow Basquiat: a memoir*, Edinburgh, Canongate, 2014

Leonhard Emmerling, *Jean-Michel Basquiat: 1960-1988*, London, Taschen, 2003

Michel Nuridsany, *Basquiat. La regalità, l'eroismo e la strada (Basquiat—Kingship, Heroism, and the Street)*, Monza, Johan & Levi Editore, 2016

Pat Hackett (ed), *The Andy Warhol Diaries*, London, Pan, 1992

Phoebe Hoban, *Basquiat: a quick killing in art*, New York, Viking, 1998

DISCOGRAPHY

Debbie Harry, *KooKoo*, Chrysalis Records, 1981

DNA, *A Taste of DNA*, American Clavé, 1981

Gray, *Shades of*, Plush Safe Records, 2013 (reprint)

James Chance and the Contortions, songs from the compilation *No New York*, Antilles Records,1978

Sonic Youth, *Sonic Youth*, Neutral Records, 1982

Suicide, *Suicide: Alan Vega and Martin Rev*, Ze Records, 1980

Teenage Jesus and the Jerks, *Orphans/Less of Me*, Migraine Records, 1978

The Lounge Lizard, *Lounge Lizard*, Editions EG, 1981

FILMOGRAPHY

Edo Bertoglio, *Downtown 81 (New York Beat)*, 1981

Julian Schnabel, *Basquiat*, 1996

Paul Tschinkel and Marc H. Miller, *Young Expressionists*, ART/New York No. 19, 1982/83

Sara Driver, *Boom for Real: The Late Teenage Years of Jean-Michel Basquiat*, 2017

Tamra Davis, *Jean-Michel Basquiat: The Radiant Child*, 2009

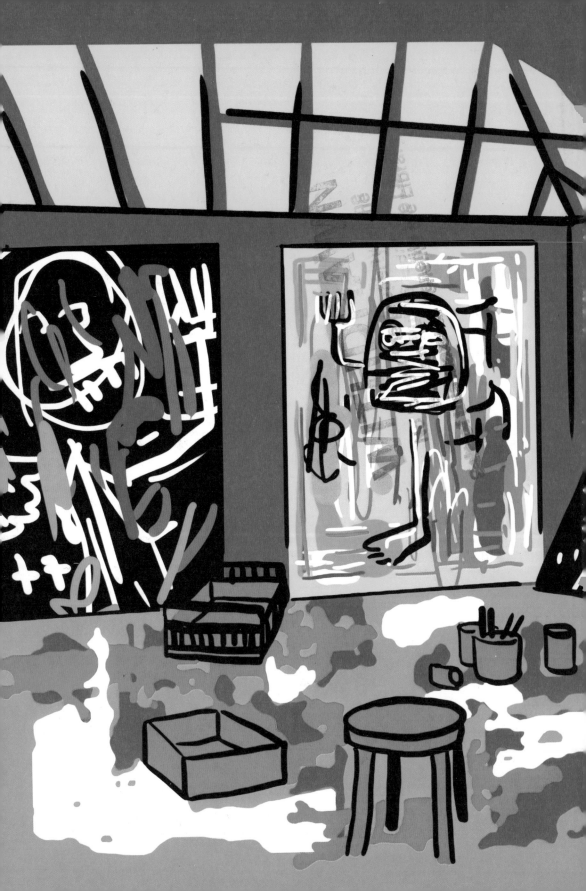